Kerry
in Pictures

Michael Diggin

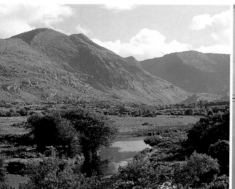 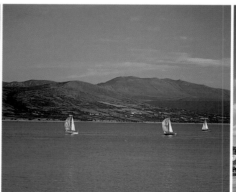 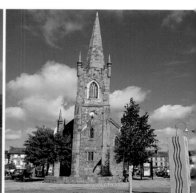

Kerry
in Pictures

Michael Diggin

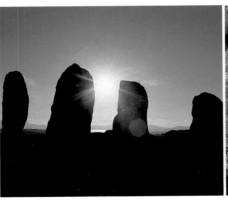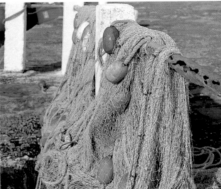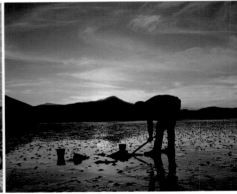

The Collins Press

First published in 2000 by
The Collins Press,
West Link Park,
Doughcloyne,
Wilton,
Cork.

A CIP Catalogue record for this book is available from the British Library.

Printed in Spain

Graphic design by Jackie Raftery

ISBN: 1-898256-97-7

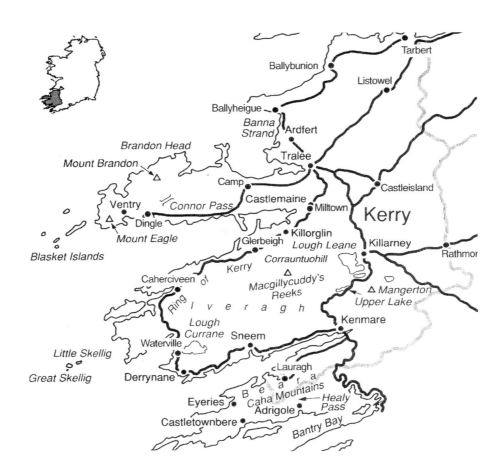

Tarbert

Ballybunion

Listowel

Ballyheigue

Banna Strand

Ardfert

Tralee

Castleisland

Brandon Head

Mount Brandon

Camp

Connor Pass

Castlemaine

Ventry

Milltown

Kerry

Dingle

Mount Eagle

Glerbeigh

Killorglin

Killarney

Rathmor

Lough Leane

Blasket Islands

Caherciveen

of

Kerry

Corrauntuohill

Macgillycuddy's Reeks

△ *Mangerton*

Upper Lake

Ring

I v e r a g h

Kenmare

Lough Currane

Sneem

Waterville

Little Skellig

Lauragh

B e a r a

Great Skellig

Derrynane

Caha Mountains

Healy Pass

Eyeries

Adrigole

Castletownbere

Bantry Bay

Location map of Kerry

Dedicated to my wife Pat

Kerry
in Pictures

by Michael Diggin

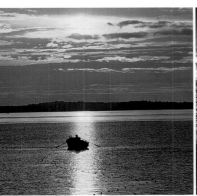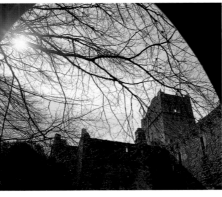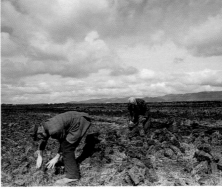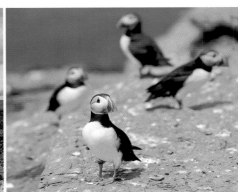

This book celebrates the singular beauty of Kerry and reflects Michael Diggin's ongoing love affair with his native county.

Kerry differs from the rest of Ireland because of its unique combination of landscape, weather, scenery and people. It is a place of dramatic mountains, bogs, rivers, romantic lakes, graceful trees and rugged coastline. The widespread occurrence of water – rivers, lakes, sea and rain – provides a moisture-laden landscape with often dramatic lighting effects. Its peninsular form and mountainous nature further provide many vantage points from which to view this remarkable landscape of contrasting beauty.

Kerry in Pictures takes you on a fascinating tour of the county. In a series of mesmerising atmospheric images Michael Diggin encapsulates all that is special about Kerry and clearly shows why it is Ireland's premier visitor destination. Using the dramatic landscape as a backdrop he vibrantly captures the spirit and colour of all that is best in Kerry. In addition to scenery, flora and fauna, buildings and towns, the warmth and relaxed lifestyle of Kerry comes alive in this collection.

With more than 100 stunning photographs and personal captions, Michael Diggin has created a timeless tribute to the beauty and character of the kingdom of Kerry. Join him on a tour of an extended Ring of Kerry.

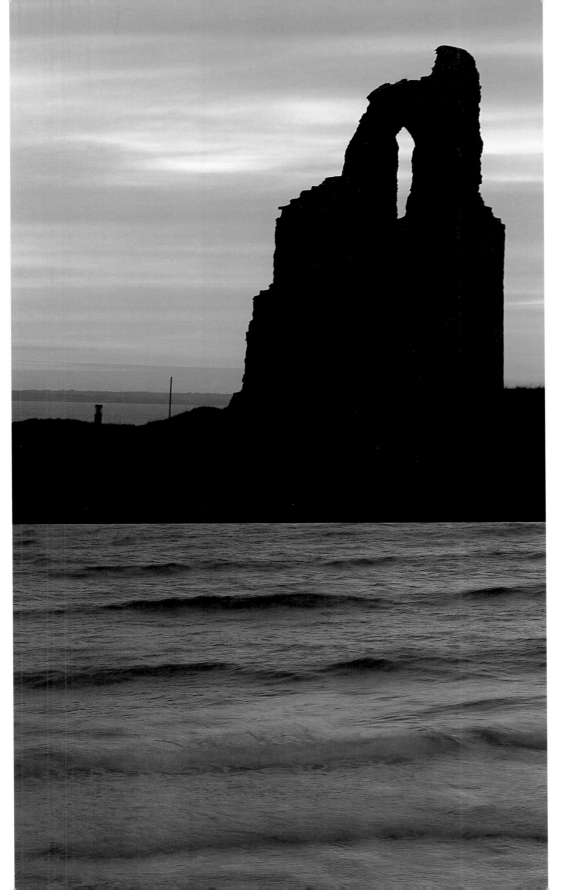

The ruined Fitzmaurice Castle at Ballybunion overlooks the mouth of the River Shannon and the Atlantic Ocean.

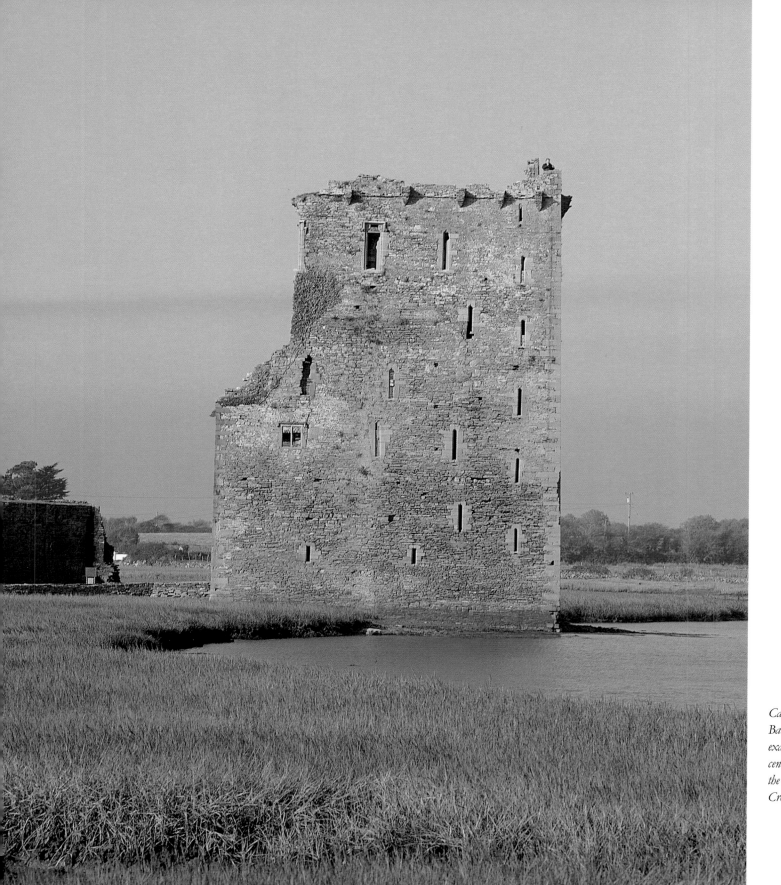

Carrigafoyle Castle near Ballylongford is a fine example of a fifteenth-century tower house. In 1649 the castle was destroyed by Cromwellian forces.

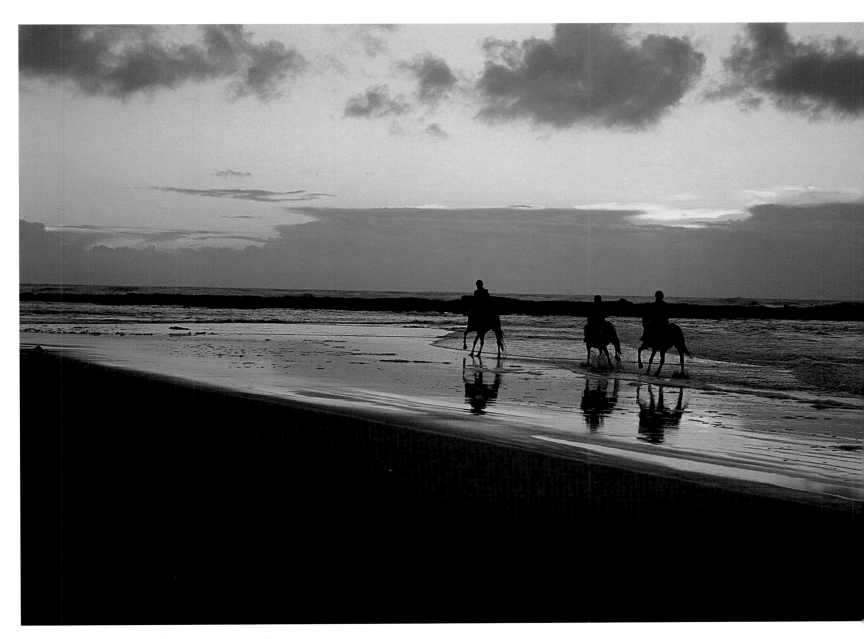

Beaches are popular for horse riding as this scene on Ballybunion beach shows.

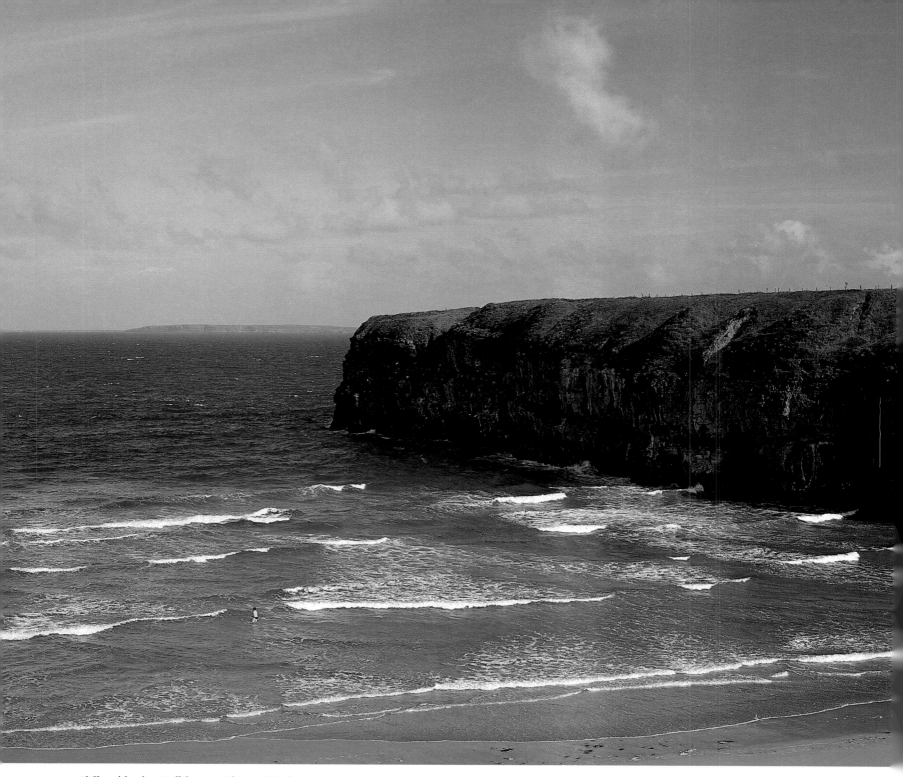

Cliffs and beach at Ballybunion with Loop Head
in County Clare in the background.

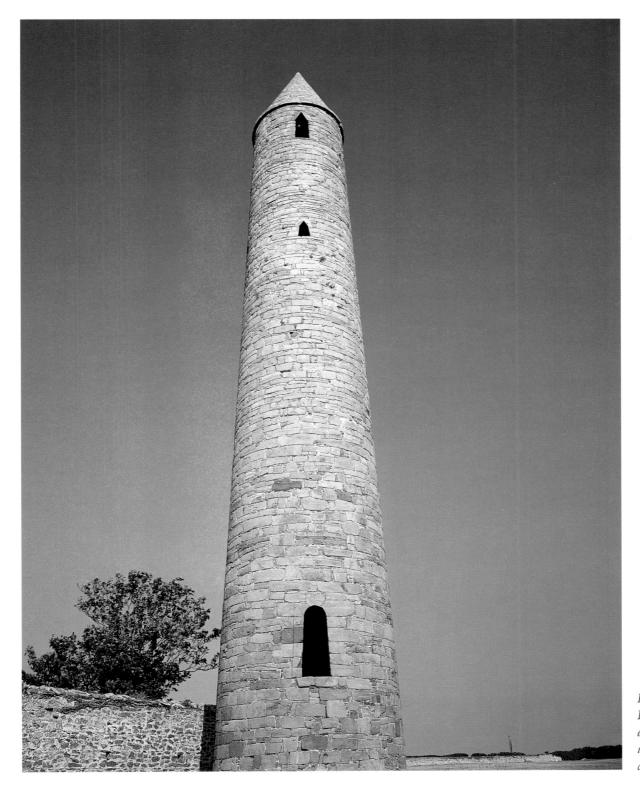

Rattoo Round Tower near Ballyduff, one of the most elegant and well-preserved in the country, is the only complete one in Kerry.

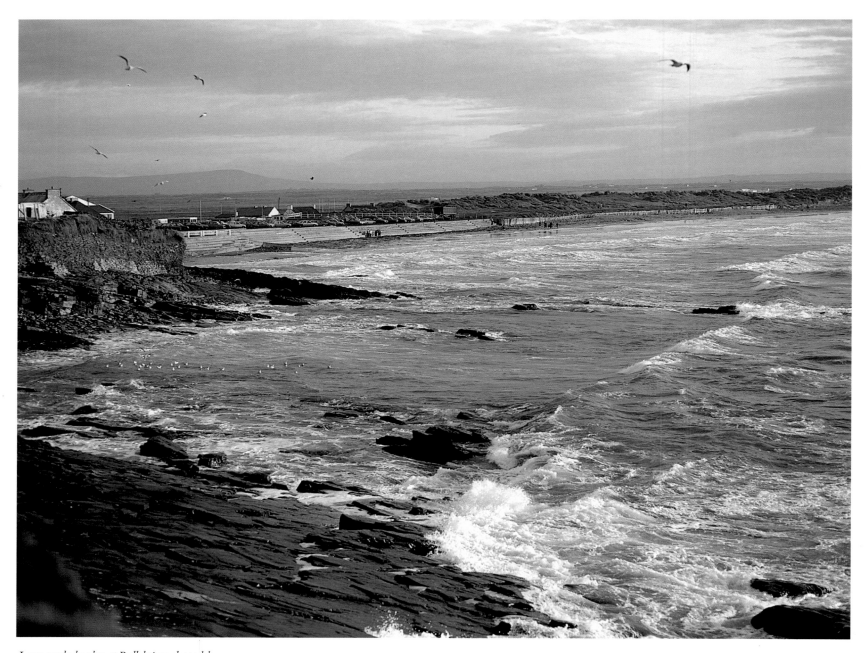

Long sandy beaches at Ballyheigue, lapped by the Gulf Stream, enjoy some of the best weather in Kerry.

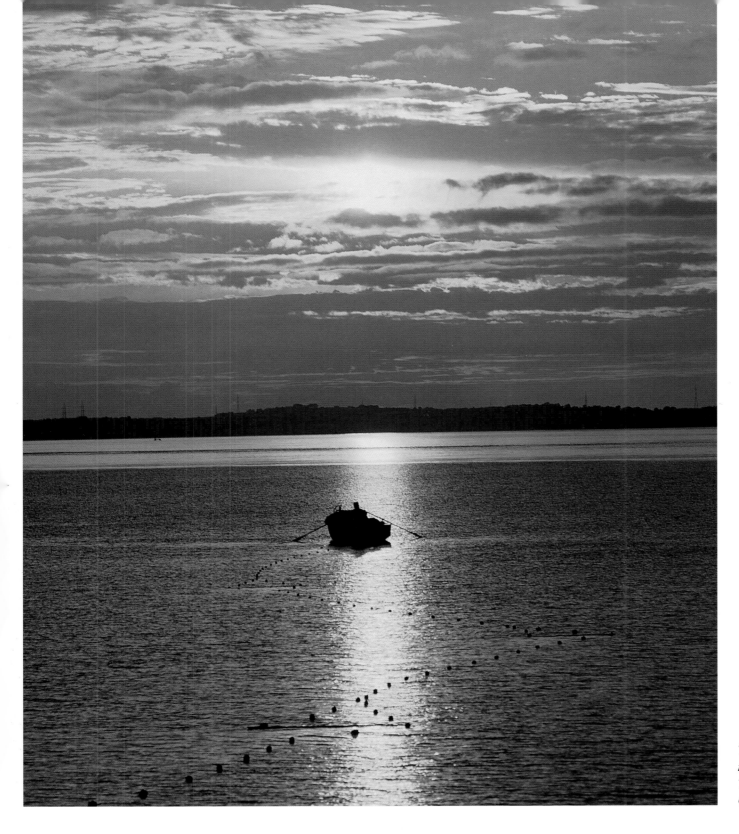

Traditional fishermen in the evening sun near Tarbert with County Clare in the distance.

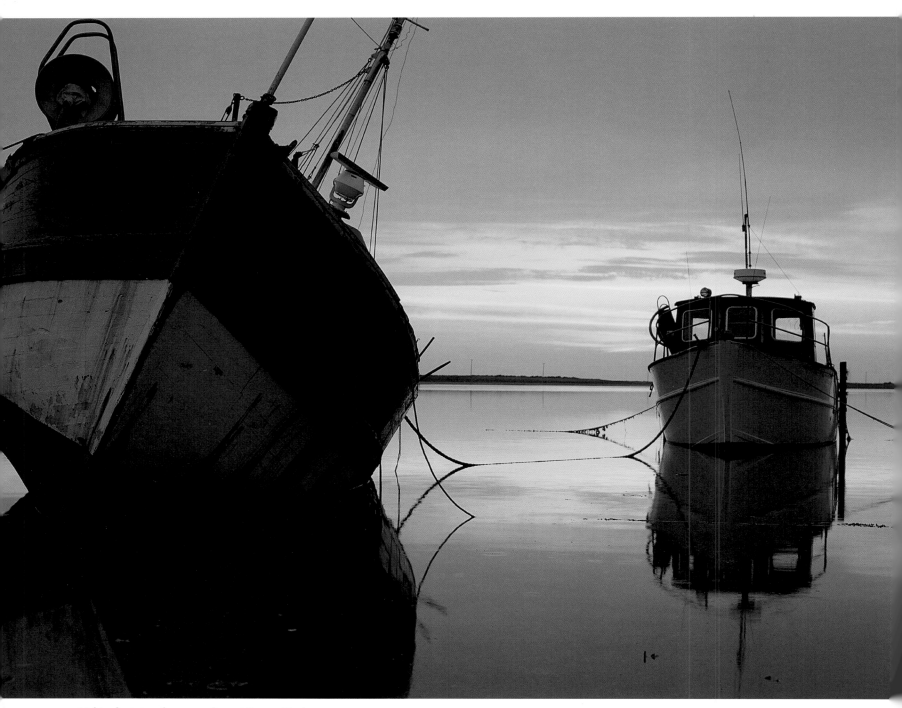

Fishing boats in calm surroundings at Barrow Harbour,
a tranquil backwater of Tralee Bay.

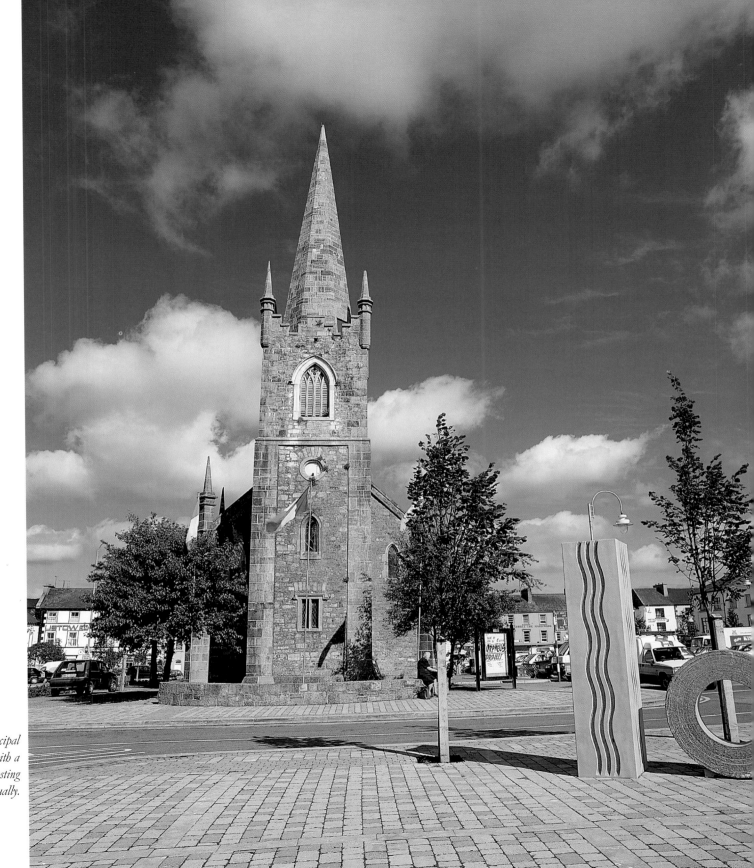

Listowel is one of the principal towns in north Kerry, with a strong literary tradition, hosting the Writers' Week annually.

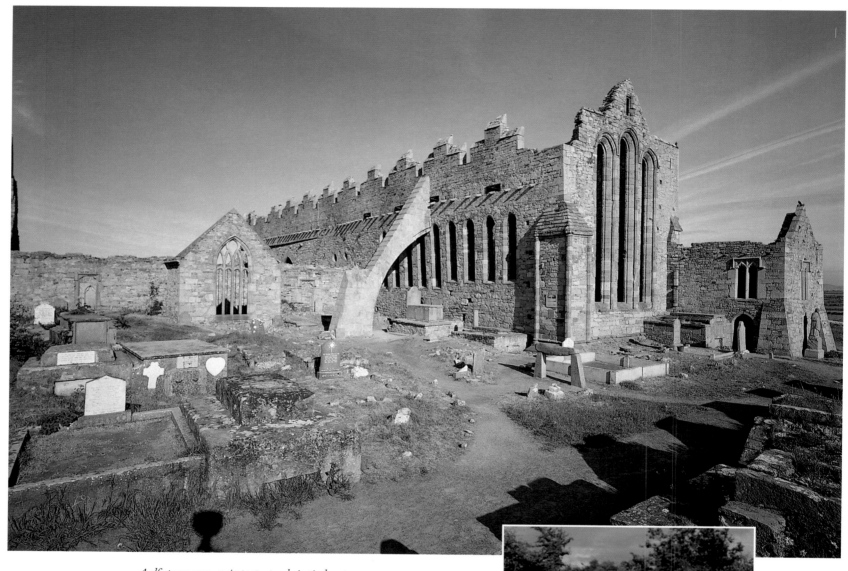

*Ardfert was once an important ecclesiastical centre
and St Brendan's Cathedral, built about 1250,
is a fine example of medieval church architecture.
Wedders Well is still a place of pilgrimage where
the altar has fine religious carvings.*

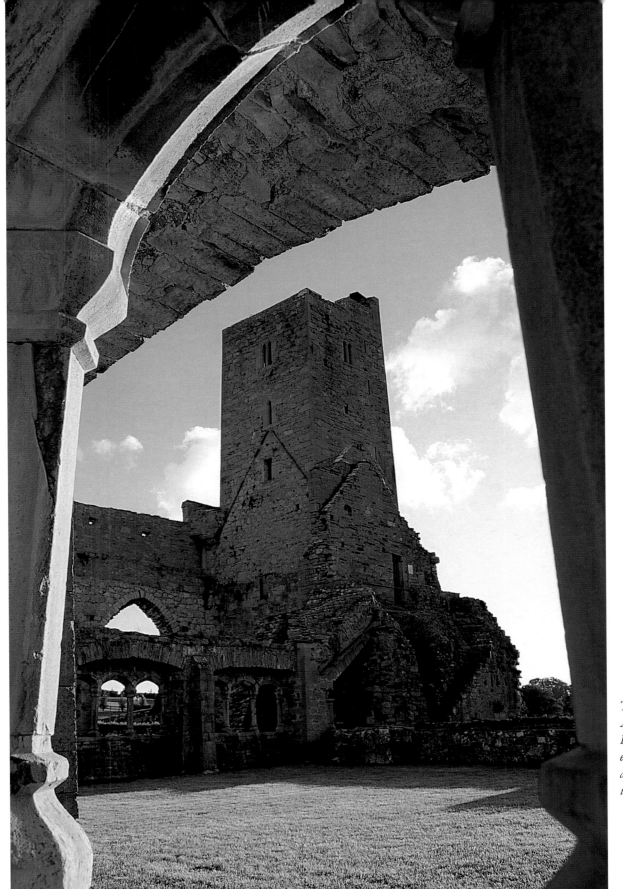

The Franciscan Friary at Ardfert, also built about 1250, is another fine example of church architecture and functioned into the 1800s.

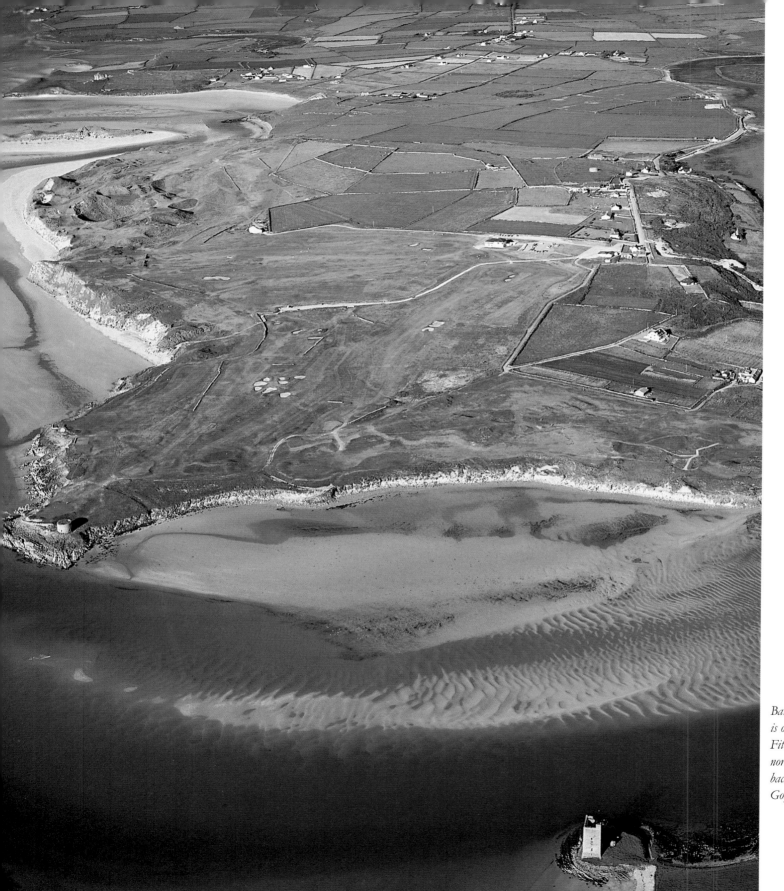

Barrow Harbour Castle is one of the many Fitzmaurice castles in north Kerry. In the background is Tralee Golf Club.

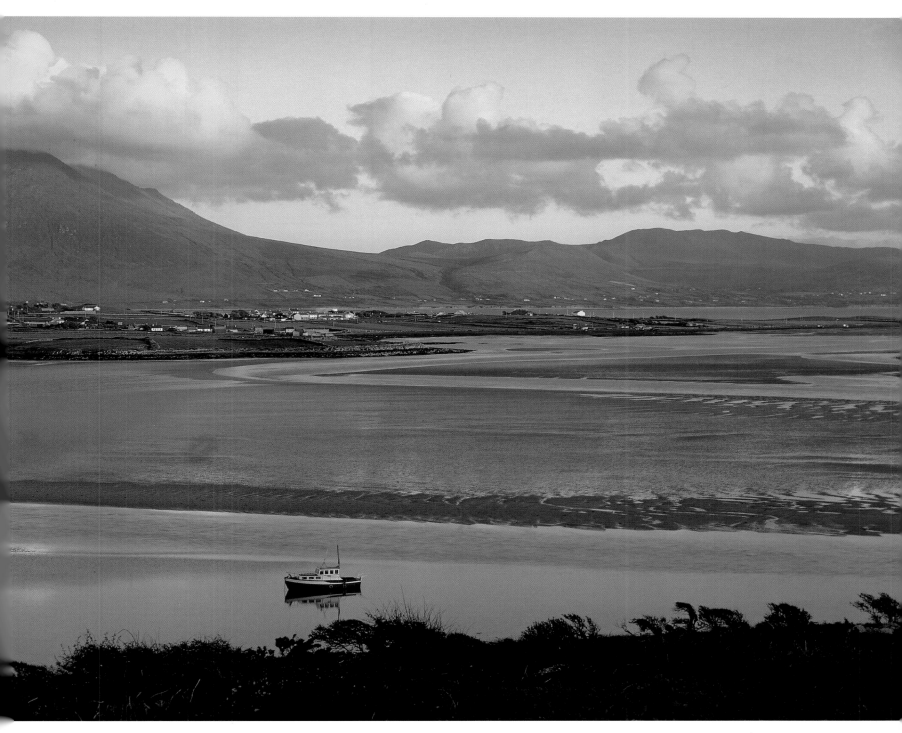

Barrow Harbour and Fenit in Tralee with the Slieve Mish Mountains
of the Dingle Peninsula in the background.

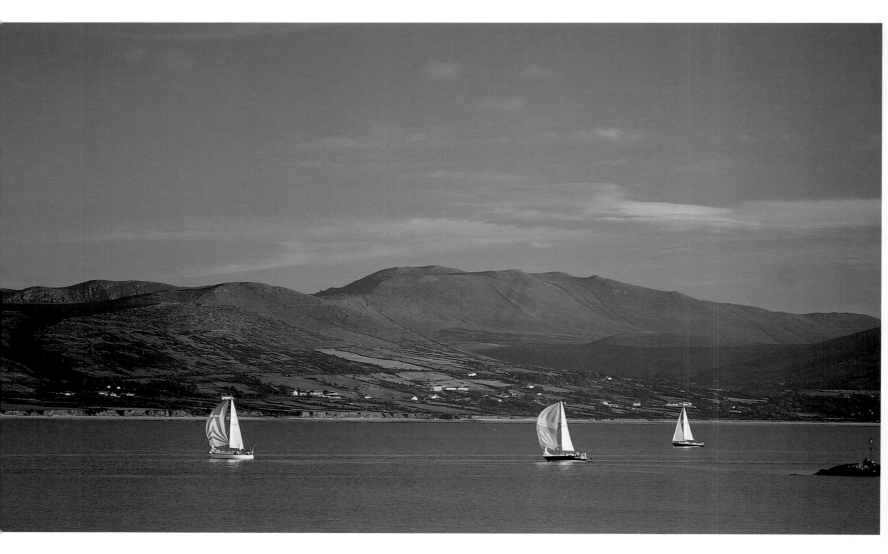

*Sailing is a popular pastime in Tralee Bay with
Fenit, which has a fine marina, being the base for
Tralee Sailing Club and the RNLI lifeboat.*

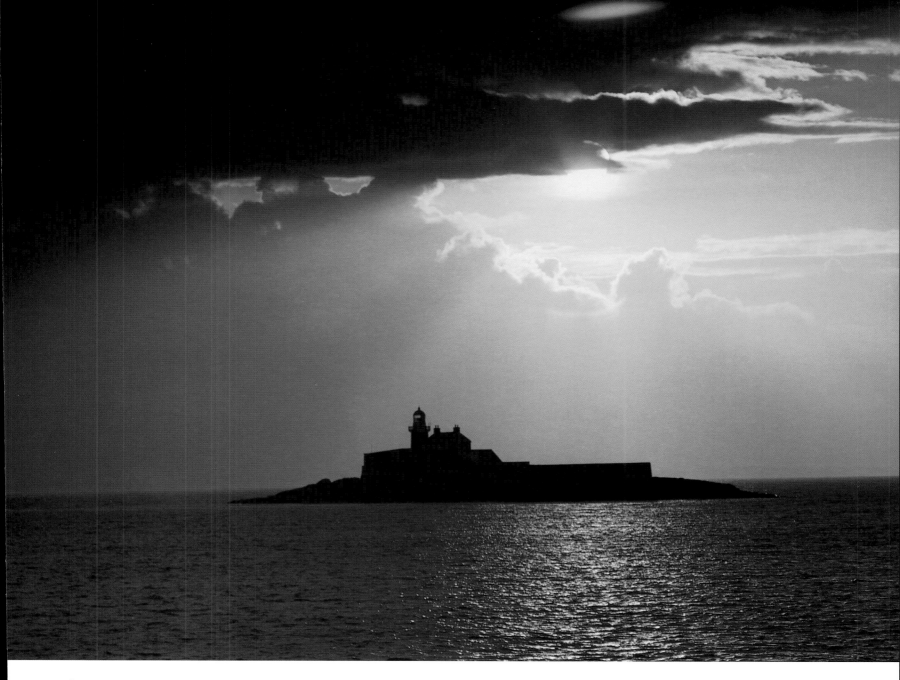

Little Samphire Island is a landmark in Tralee Bay.
The lighthouse is no longer manned due to automation.

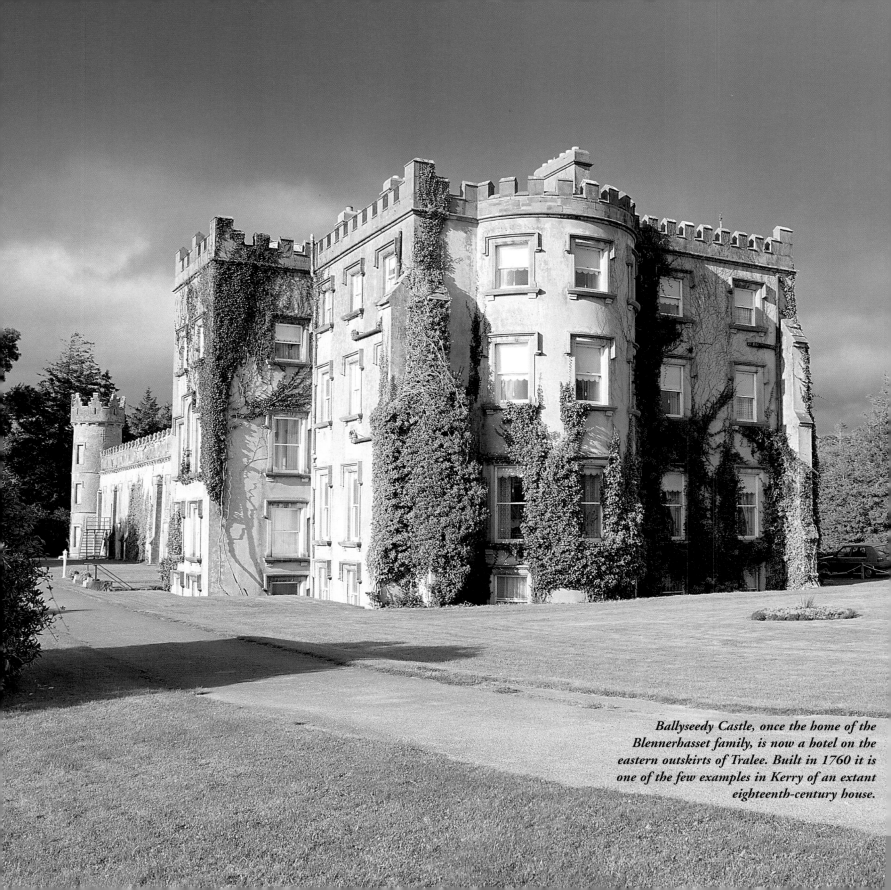

Ballyseedy Castle, once the home of the Blennerhasset family, is now a hotel on the eastern outskirts of Tralee. Built in 1760 it is one of the few examples in Kerry of an extant eighteenth-century house.

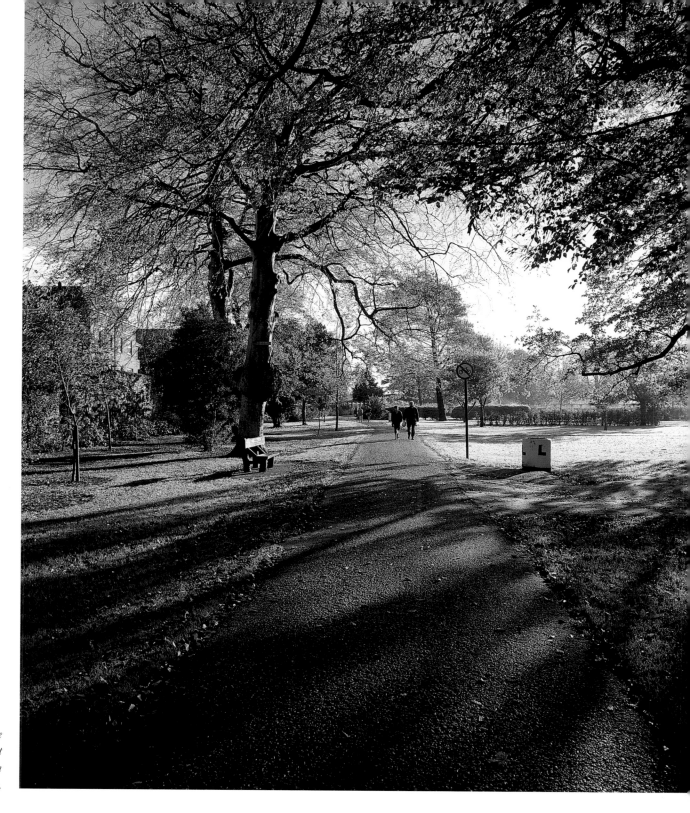

Tralee Town Park, once part of the Denny Estate, is a pleasant retreat with fine deciduous trees and an international collection of roses.

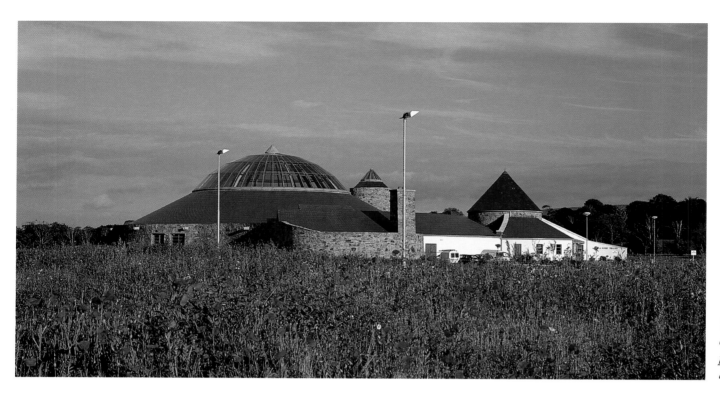

The Aquadome in Tralee, opened in 1994, features various pools, waves, geysers and other attractions.

Siamsa Tire –The National Folk Theatre – is based in this specially-commissioned building in Tralee completed in 1991. Its design was inspired by that of Staigue Fort.

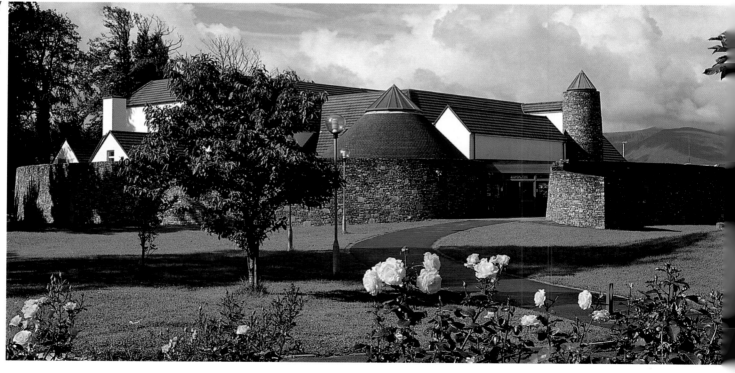

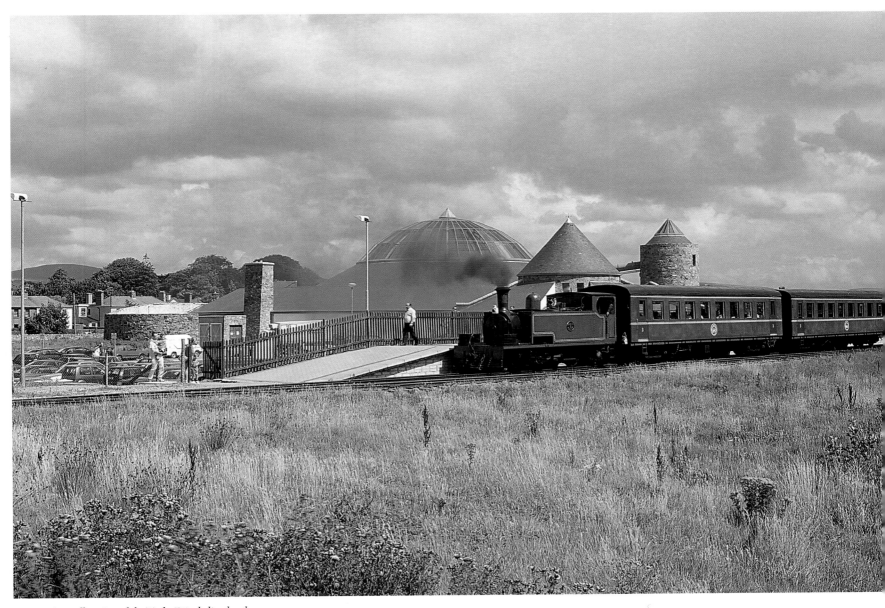

A small section of the Tralee-Dingle line has been reopened from Tralee to Blennerville. Carriages are pulled by the original steam engine which travelled from Tralee to Dingle.

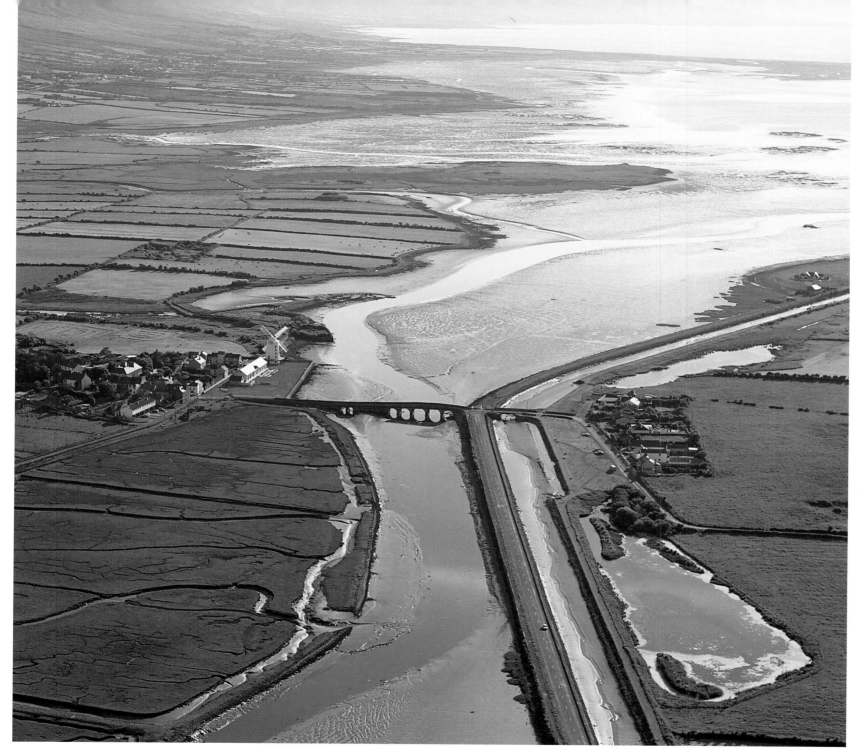

At one time the port for Tralee, Blennerville now has a restored windmill and visitor centre. The names of those who emigrated in famine times are recorded in the centre.

With its windmill now in full working order Blennerville is the gateway to the Dingle Peninsula.

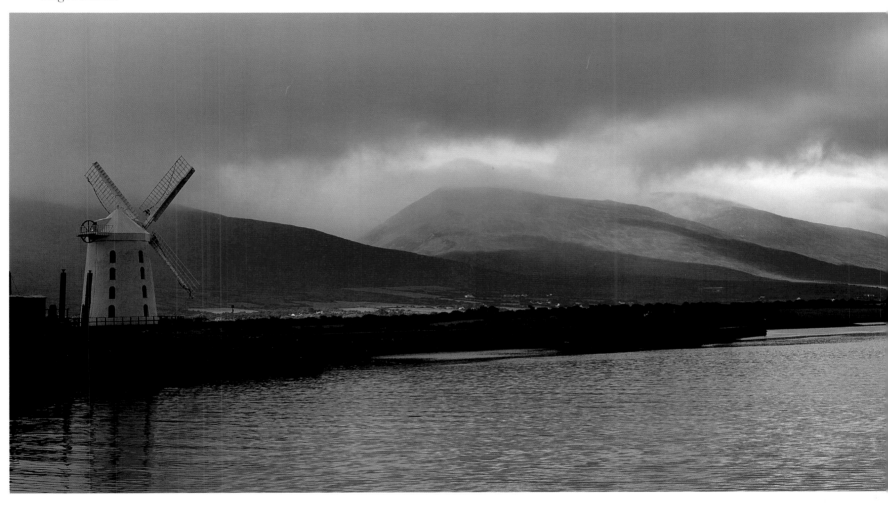

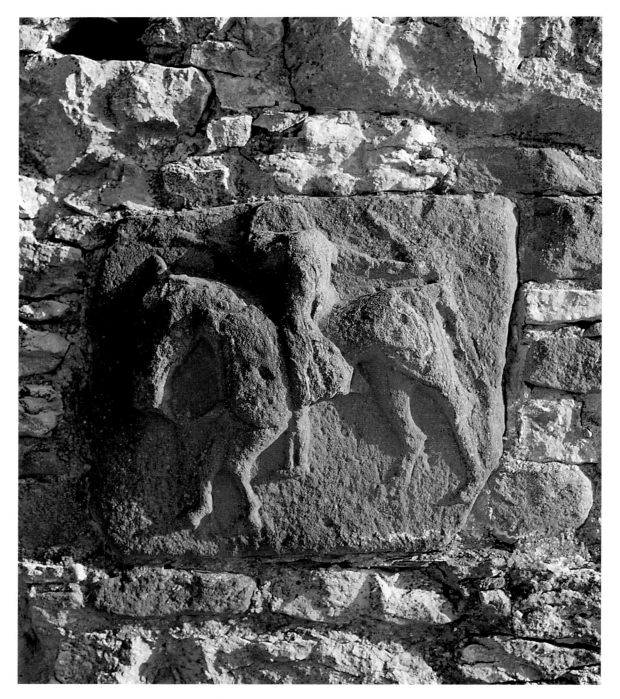

Along the Dingle road from Blennerville is Annagh church.
On its wall there is an unusual carving of a headless horseman.

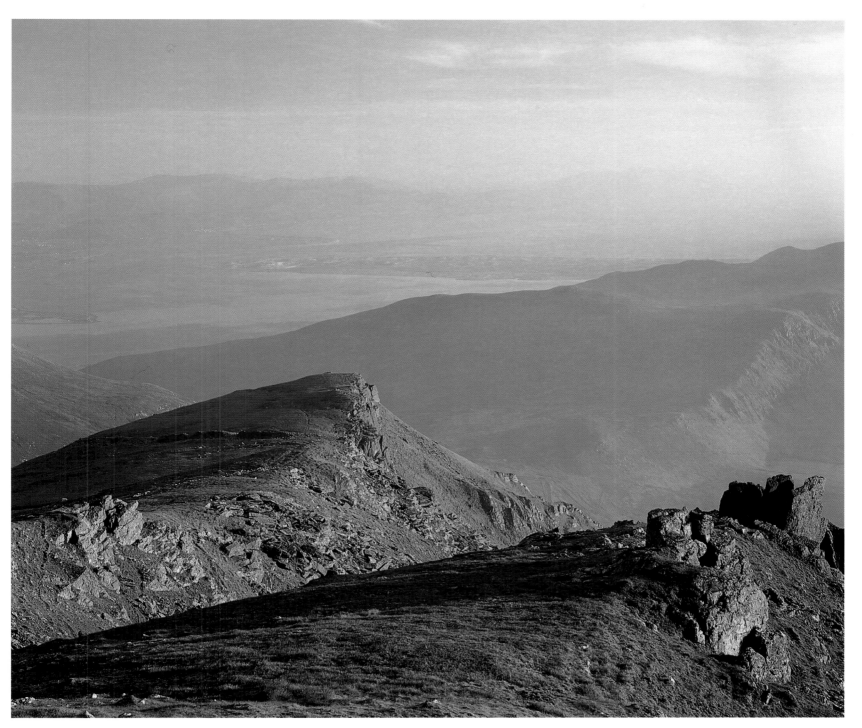

Caherconree stone fort, one of the most famous places in the legends of the Fianna, sits on top of a striking inland promontory near Camp and overlooks Dingle Bay.

23

Kerry in Pictures

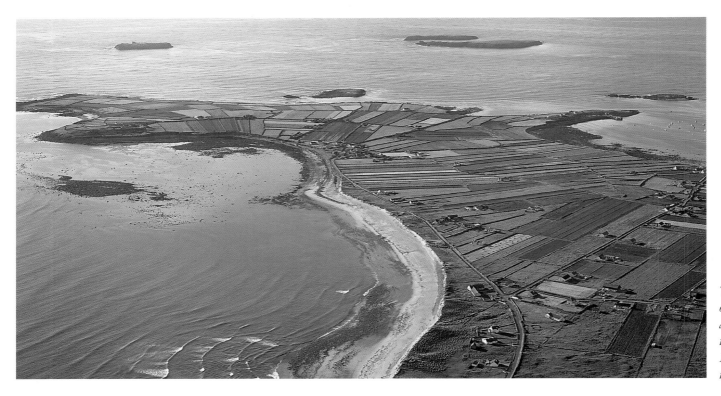

The Maharee Peninsula juts out between Tralee Bay and Brandon Bay with the Maharee or Seven Hogs Islands off the end of the peninsula.

Illauntannig, one of the Maharee Islands, contains the remains of a small monastic settlement with beehive huts, stone crosses and a burial ground.

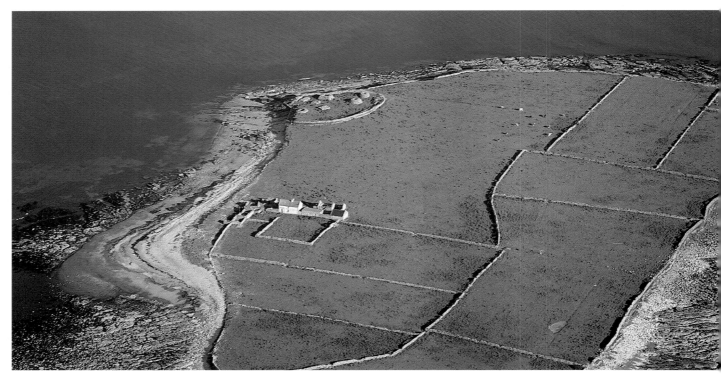

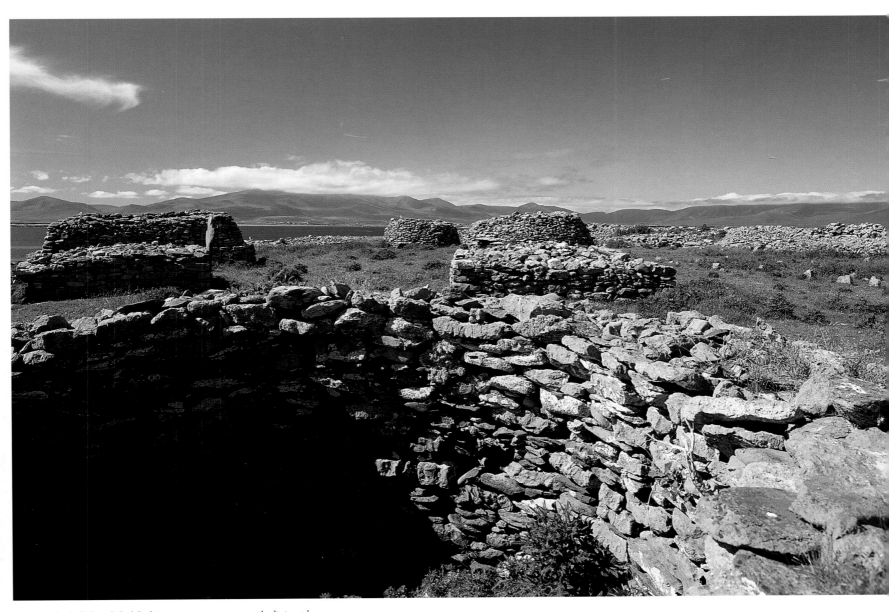

The half-demolished beehive stone structures were the living places
or cells for the monks in the monastic community.

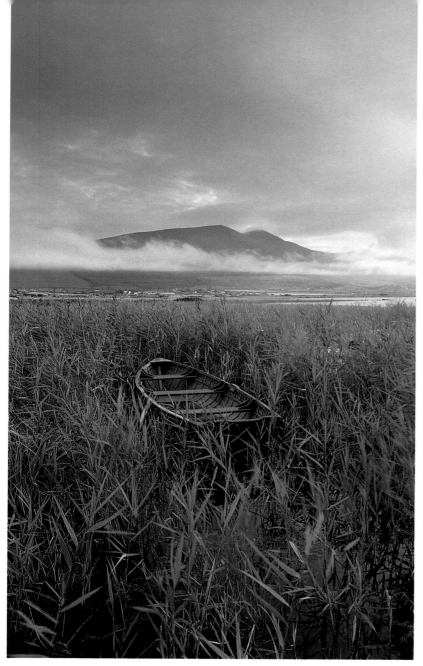

A fly fisherman on Lough Gill.

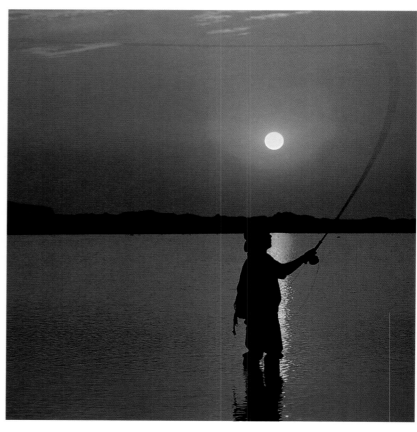

A boat at anchor in Lough Gill hidden by the reeds while Beenoskee looms out of the fog in the background.

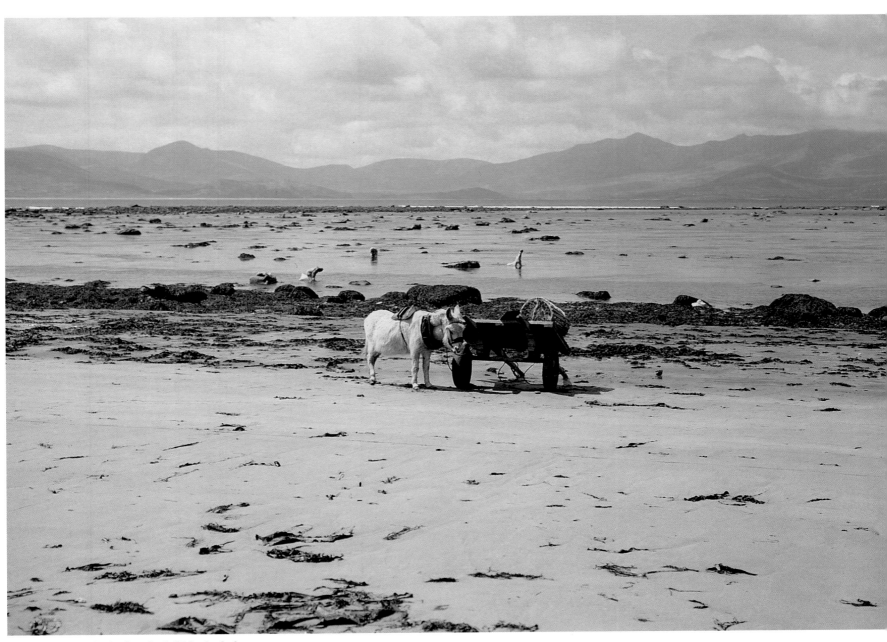

Harvesting the foreshore for shellfish after high tide with Brandon Bay and the Brandon Mountains in the distance.

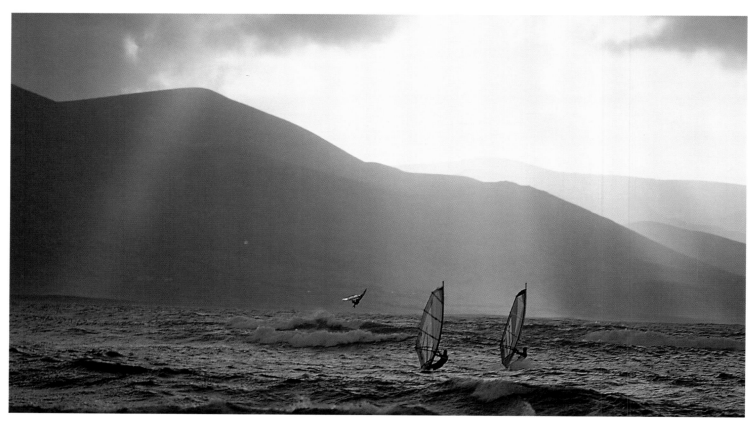

The sea provides scope for a variety of water sports and Brandon Bay is no exception.

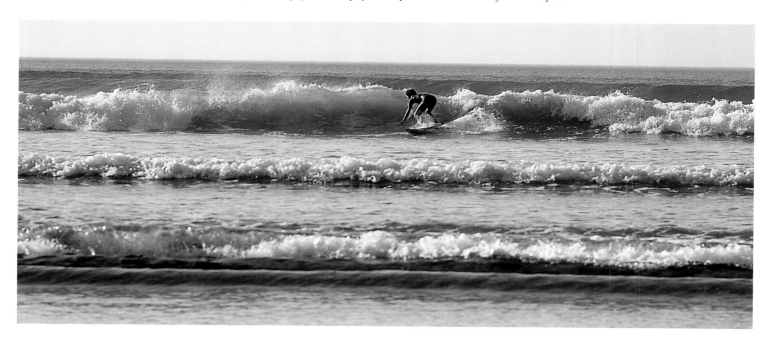

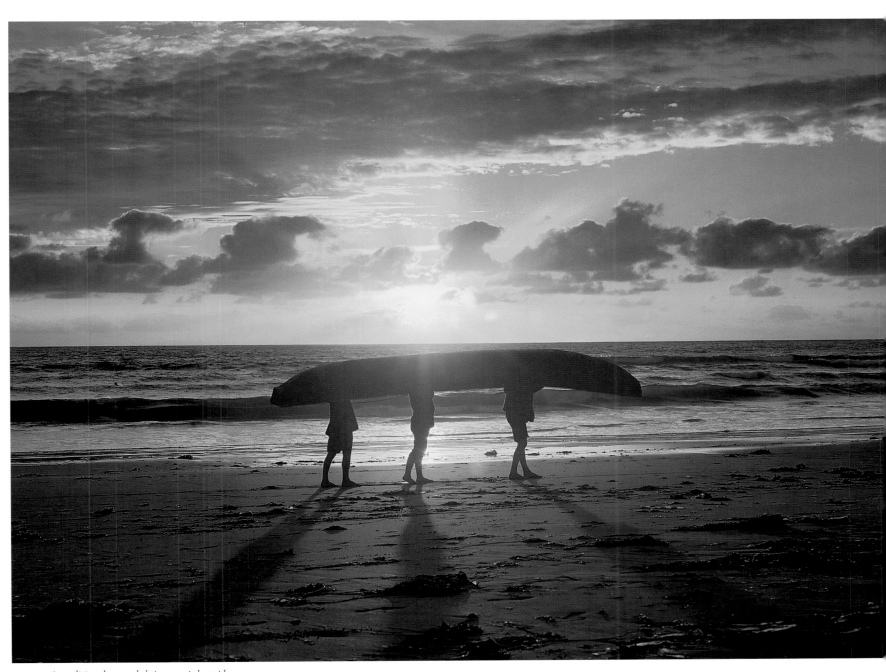

A traditional curragh being carried upside down. St Brendan is said to have sailed to America in a similar boat.

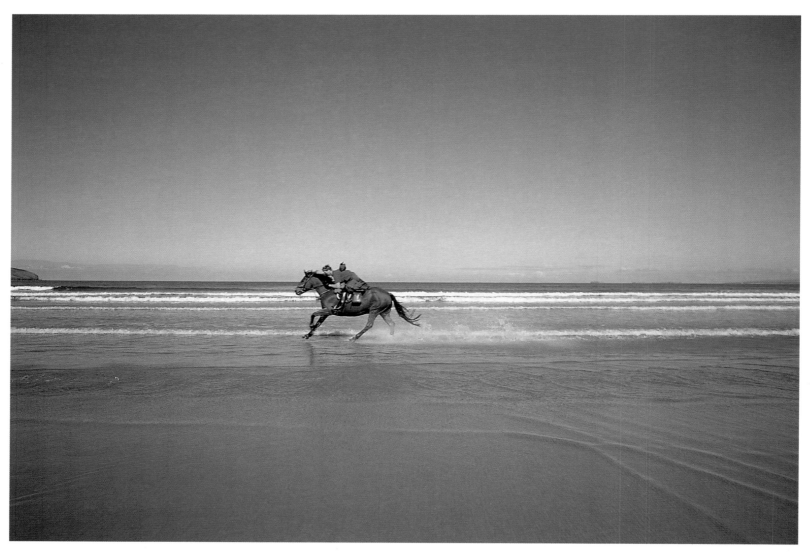

Horse riding on Fermoyle Beach with the
Atlantic Ocean as a backdrop.

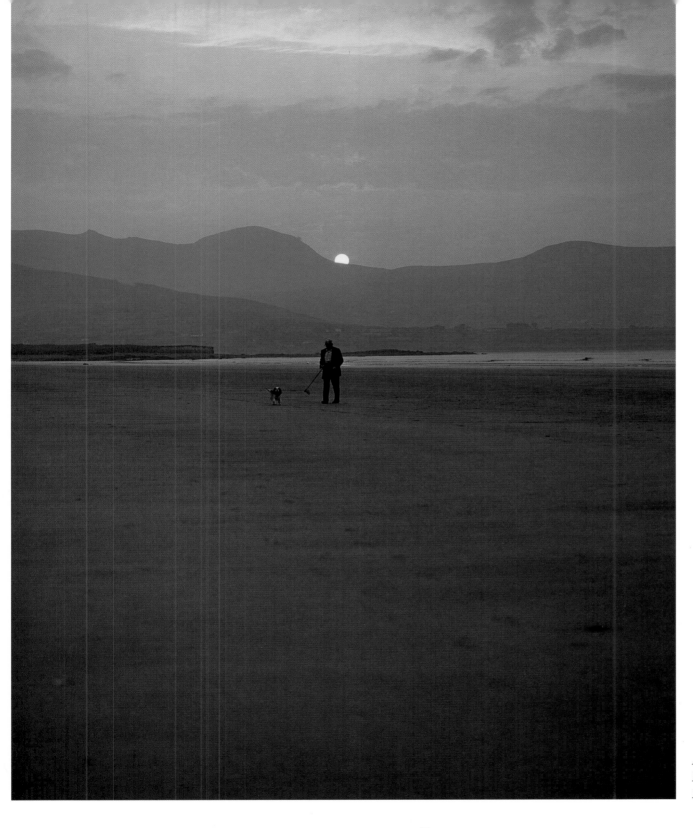

A man and his dog on Fermoyle Beach as the sun sets behind the Brandon Mountains.

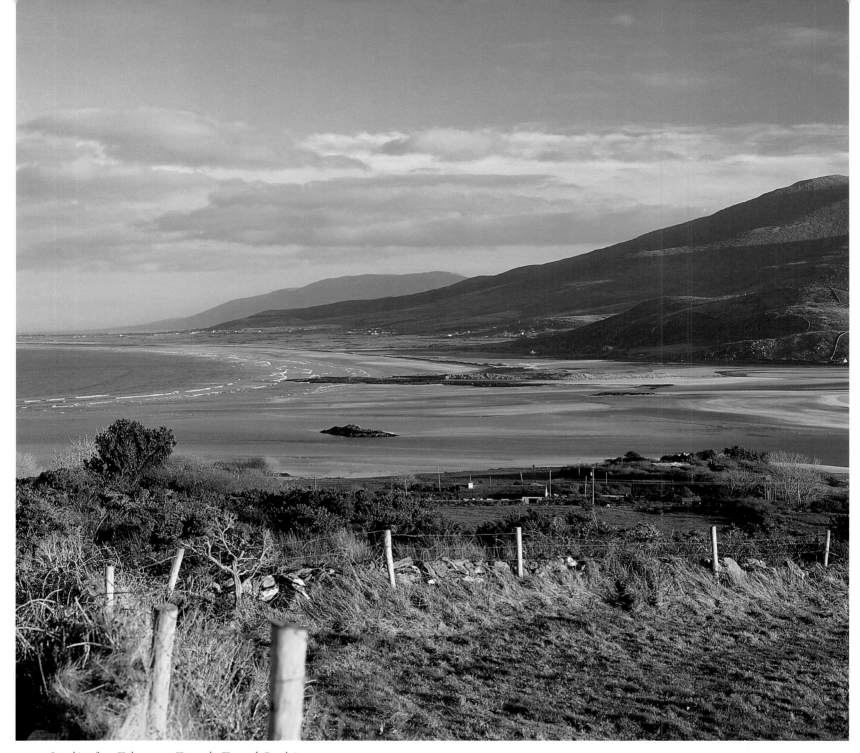

Stretching from Fahamore to Fermoyle, Fermoyle Beach is one of the longest sandy beaches in Kerry, over twelve km long.

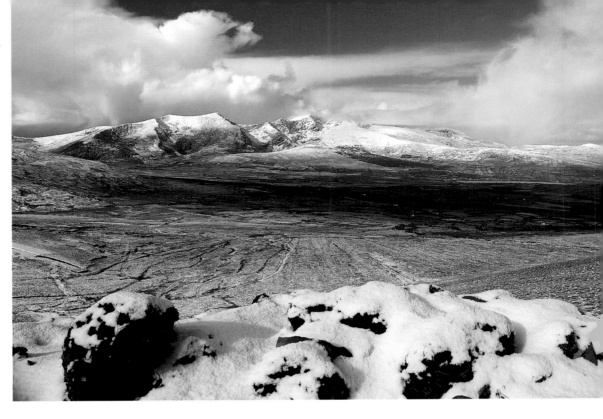

*Covered in a winter blanket of
snow, the Brandon Mountains
tower over the Owenmore Valley.*

*Looking east towards the Connor
Pass from Brandon Mountain with
Lough Cruttia just visible as it
huddles under the northern slopes.*

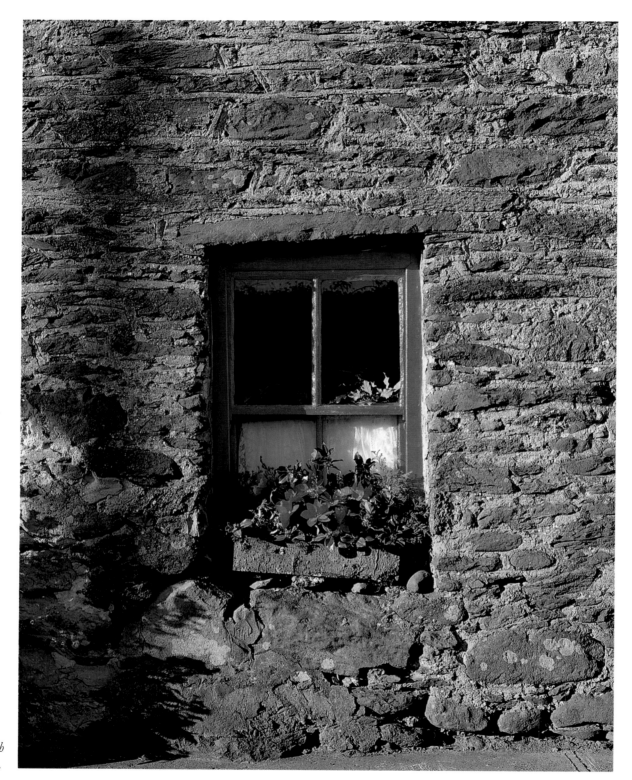

Traditional stone wall and window in the village of Cloghane, with its decorative flower box.

34

Kerry in Pictures

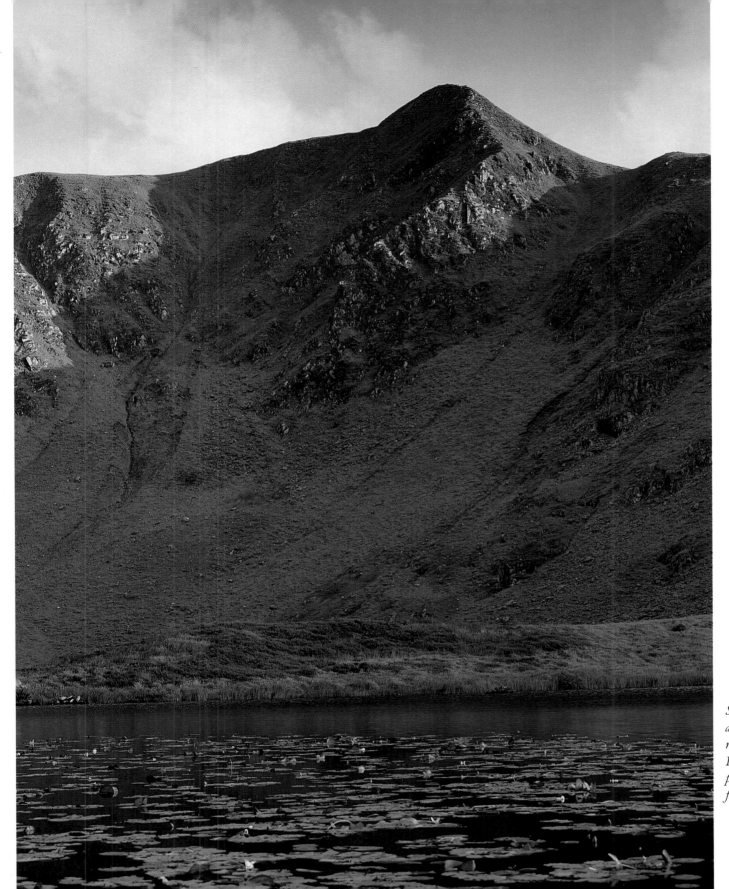

Sauce Creek, once the site of an ancient settlement, is only readily accessible from the sea. Its sheltered shores are resting places for flotsam and jetsam from the Atlantic.

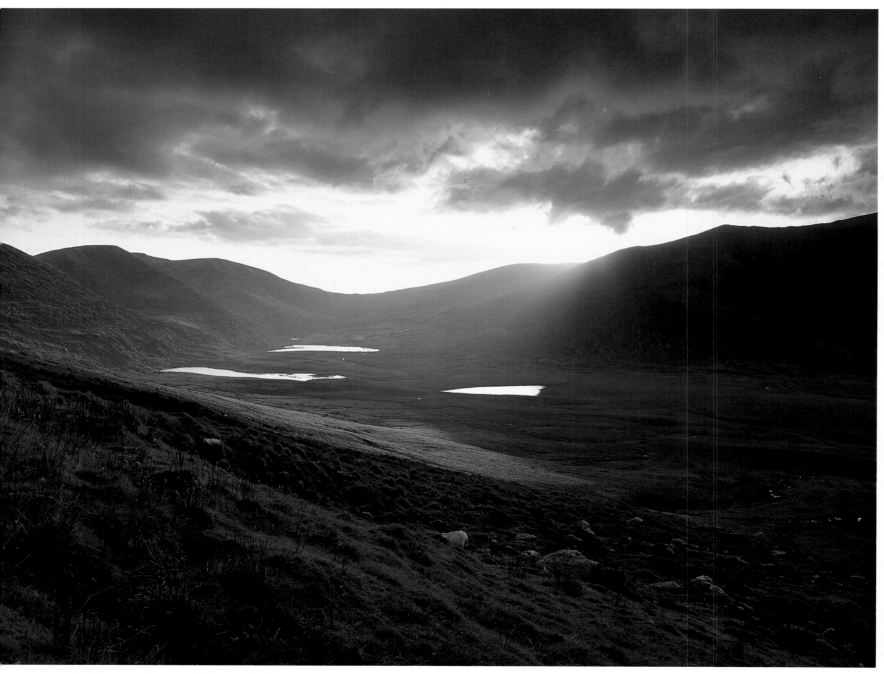

*Looking up the Owenmore Valley towards the
Connor Pass with its three lakes glistening in the
evening light.*

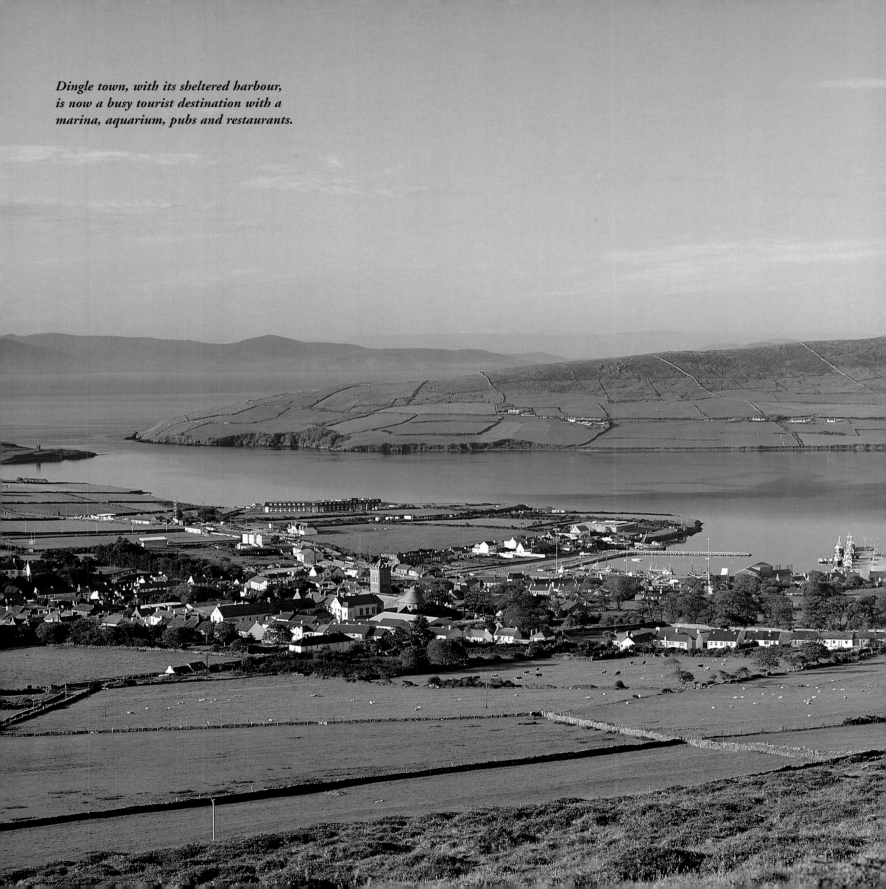

Dingle town, with its sheltered harbour, is now a busy tourist destination with a marina, aquarium, pubs and restaurants.

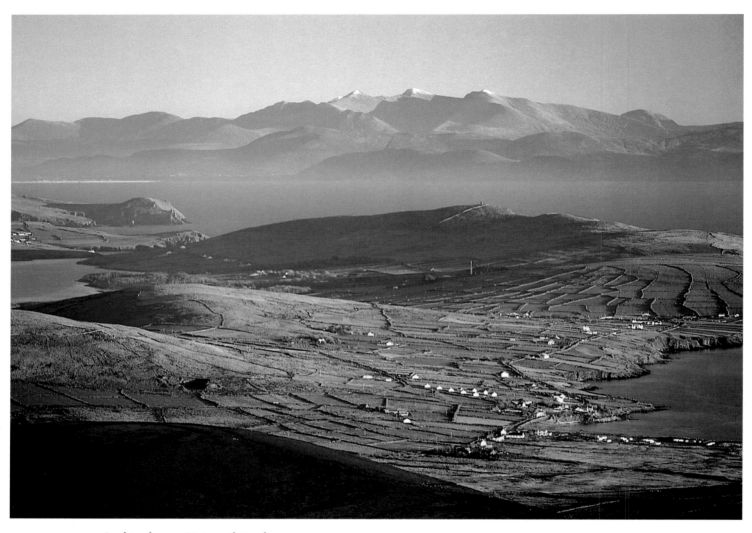

Looking down on Ventry with Dingle
Bay and the snow-covered
Macgillycuddy's Reeks beyond.

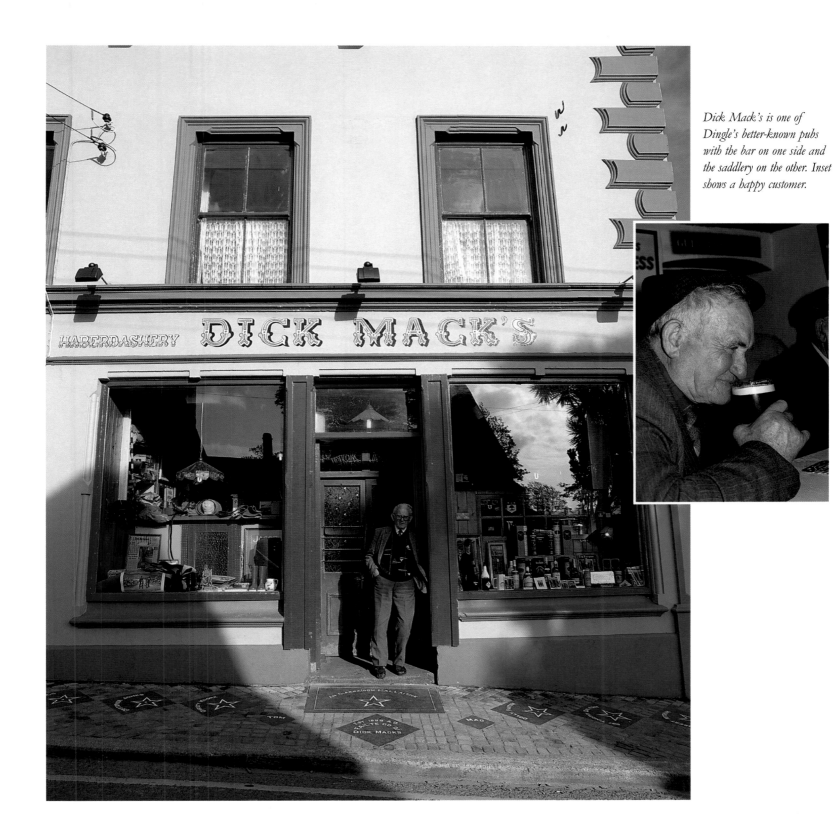

Dick Mack's is one of Dingle's better-known pubs with the bar on one side and the saddlery on the other. Inset shows a happy customer.

Dingle regatta and curragh races are an annual summer spectacle while at Christmas the Wren Boy's Parade is a major event.

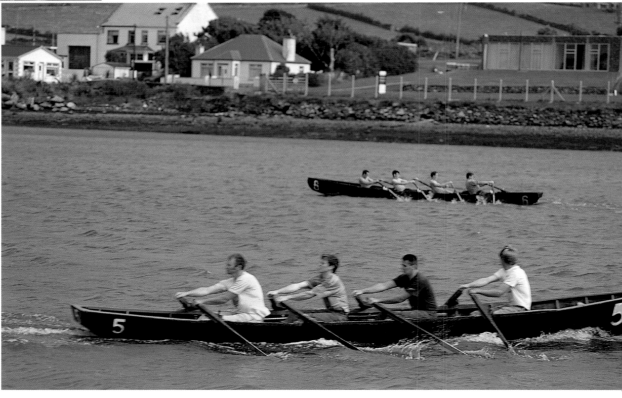

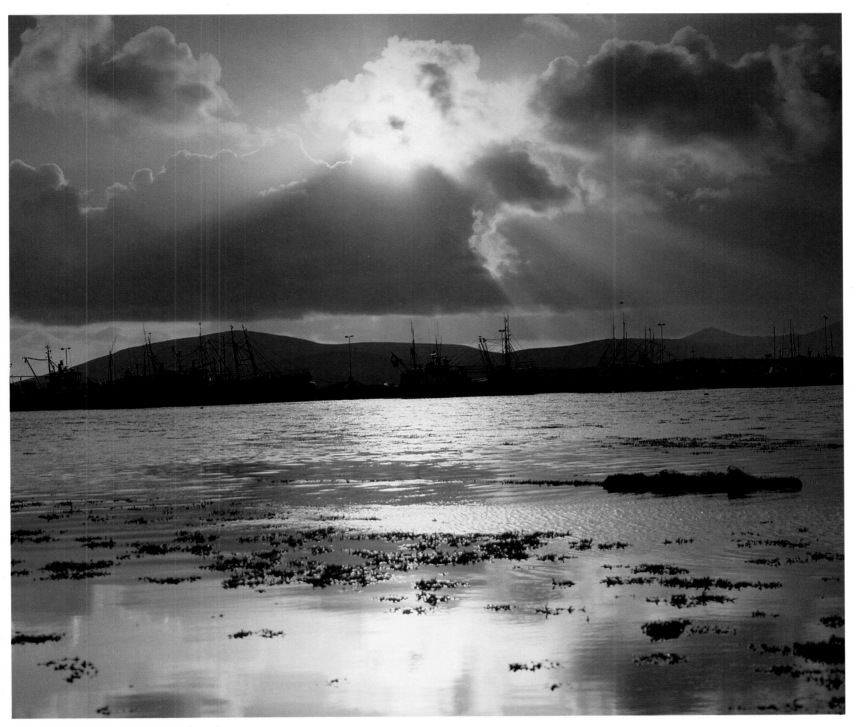

The fishing fleet tied up in Dingle Harbour.

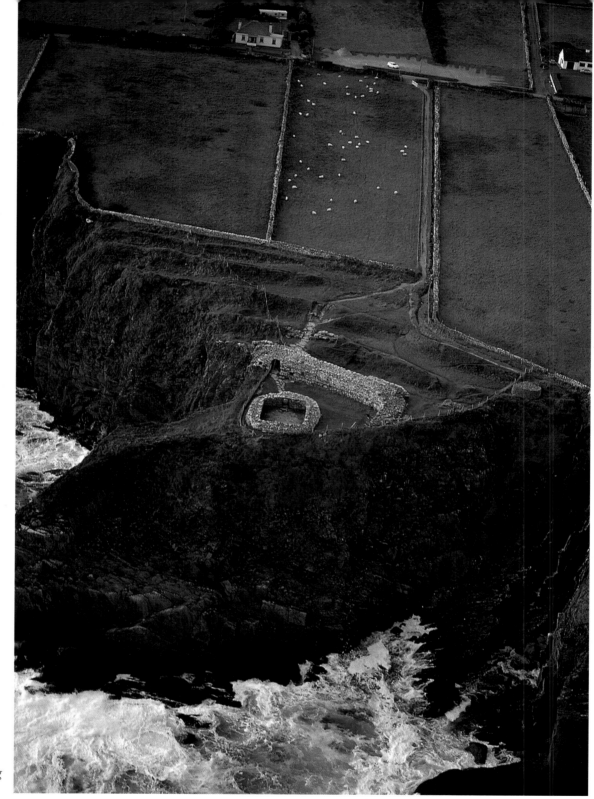

*Dunbeg Fort near Slea
Head is a striking
promontory fort with an
enormous stone wall isolating
its precarious position.*

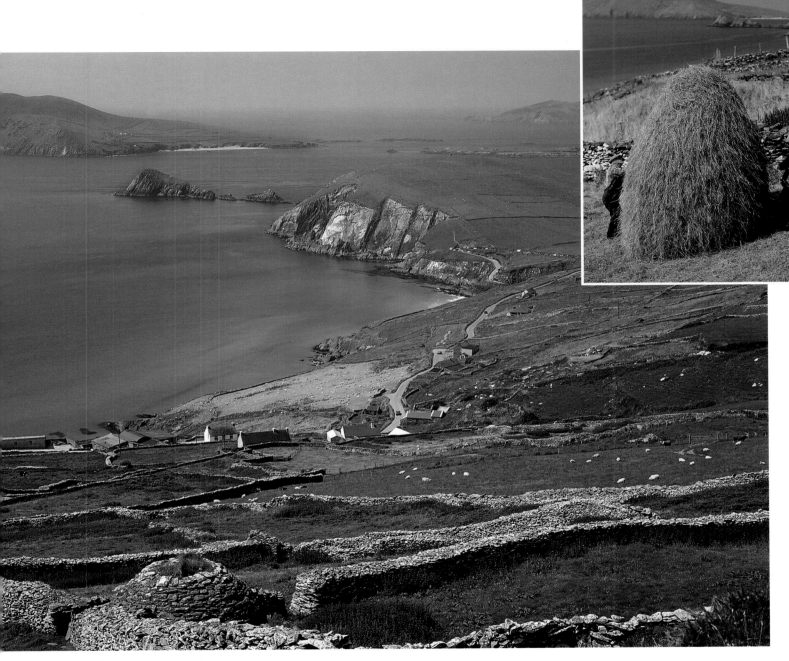

Traditional farming still survives in places as evidenced by the small holdings in this scene at Dunmore Head with (inset) hay being saved in the old style.

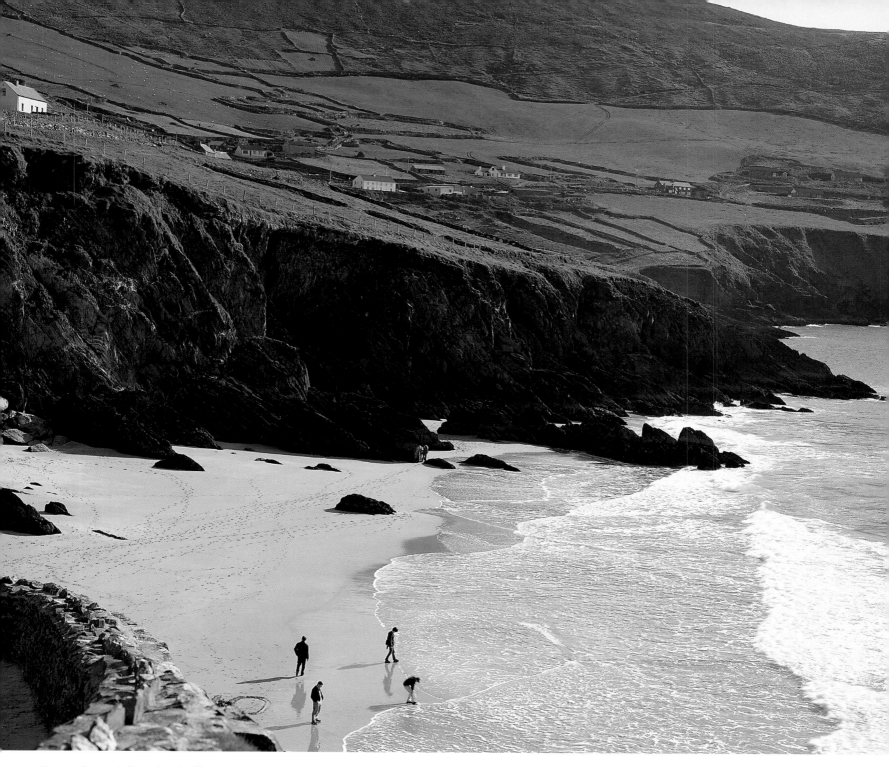

*Coumeenole Strand, featured in the film **Ryan's Daughter**,*
is a favourite though sometimes unsafe bathing place.

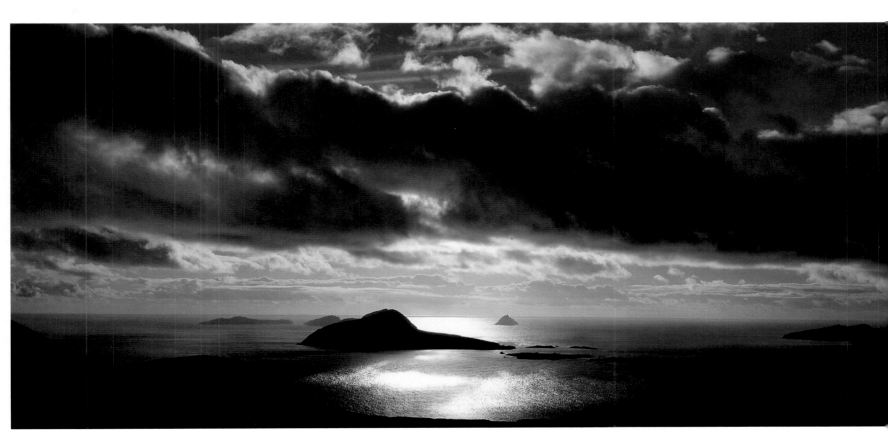

The Blasket Islands, uninhabited
since 1953, were home to a very
close-knit community which gave
rise to a number of literary
masterpieces.

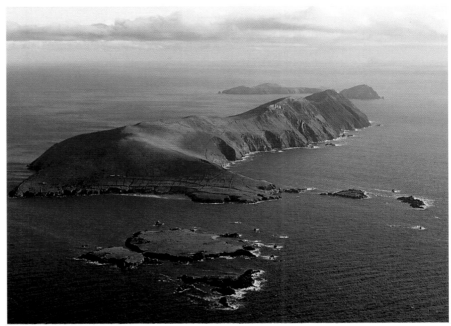

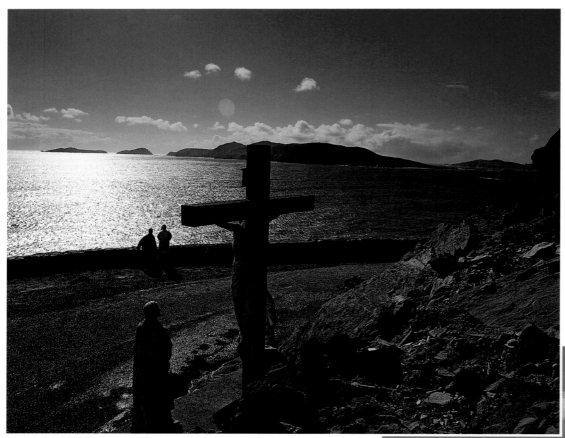

View of the Blasket Islands from the 'Calvary' at Slea Head and Inishtooskert, the northern island, silhouetted against the sea and the sky.

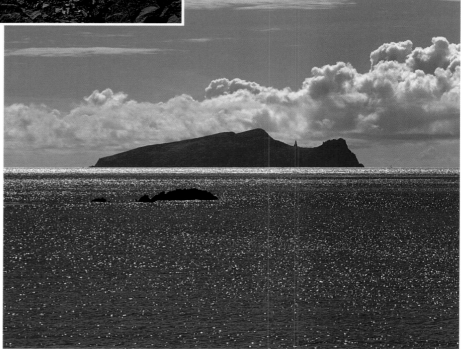

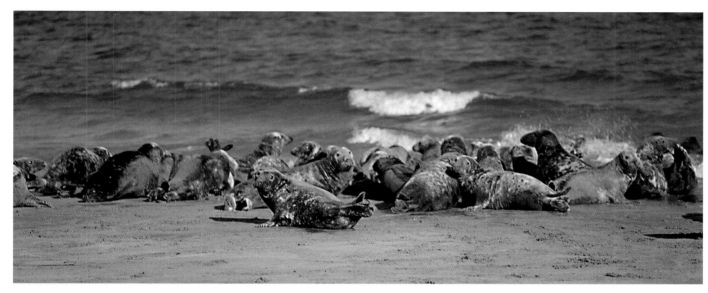

Seals on the beach of the Great Blasket Island and the remains of the former village.

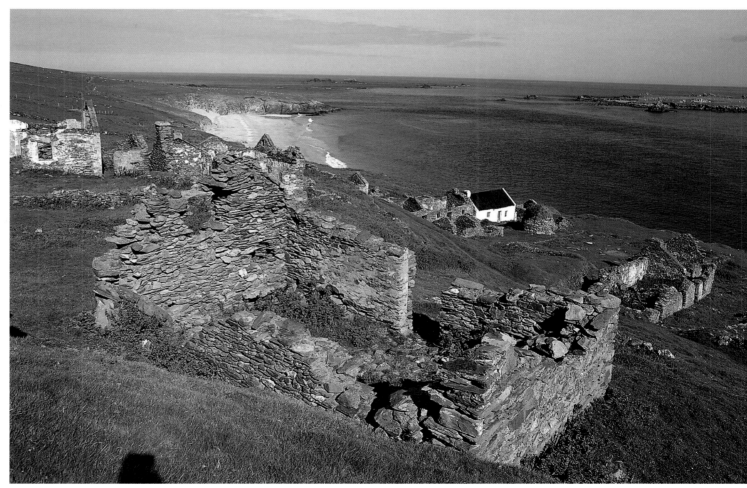

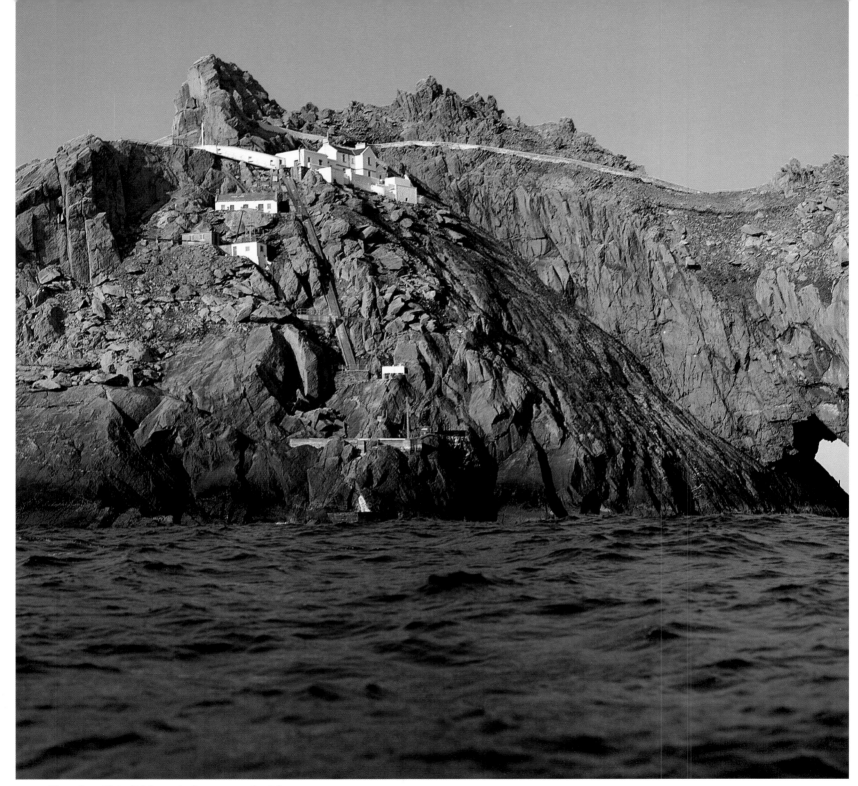

*Tearaght, with its lighthouse, is the most westerly of the
Blasket Islands and a notable breeding ground for seabirds.*

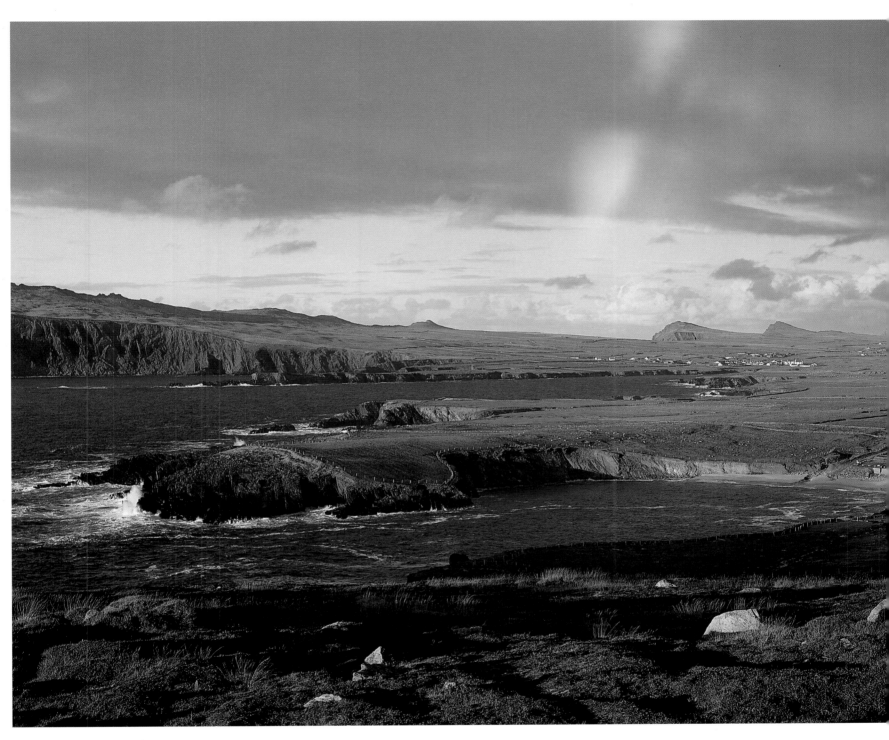

*Clogher Strand, Ferriter's Cove, Sybil Head, the Three Sisters
and Dún an Óir viewed from near Clogher Head.*

Rolling Atlantic waves breaking on Clogher Strand and
against the spine-like outline of Sybil Point.

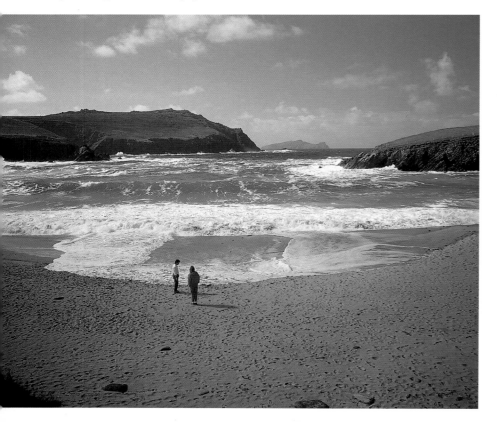

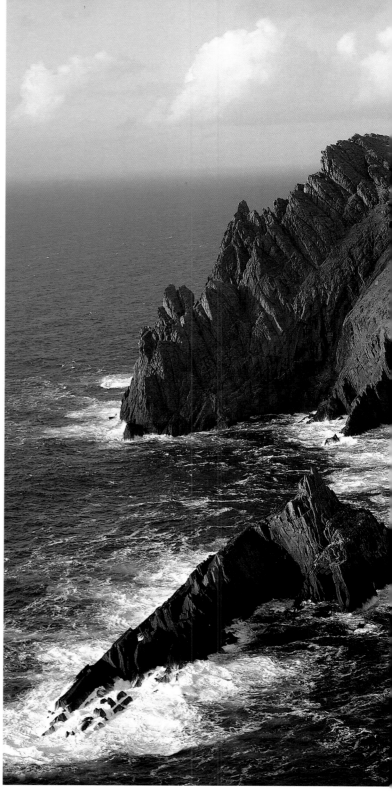

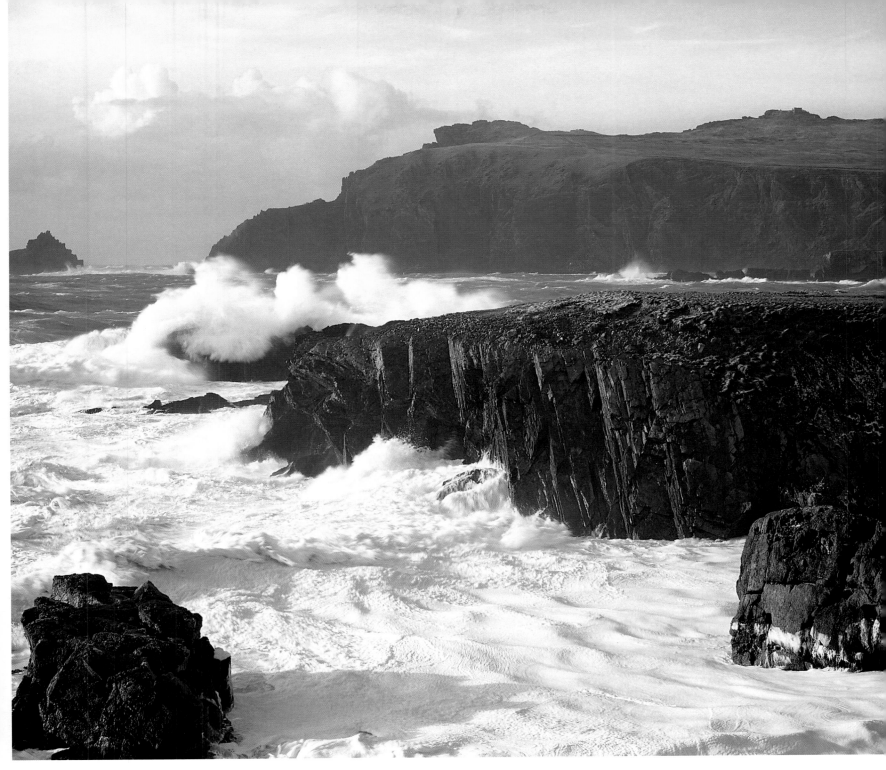

*The erosive power of the Atlantic waves is very evident from
these alternate headlands and inlets near Sybil Head.*

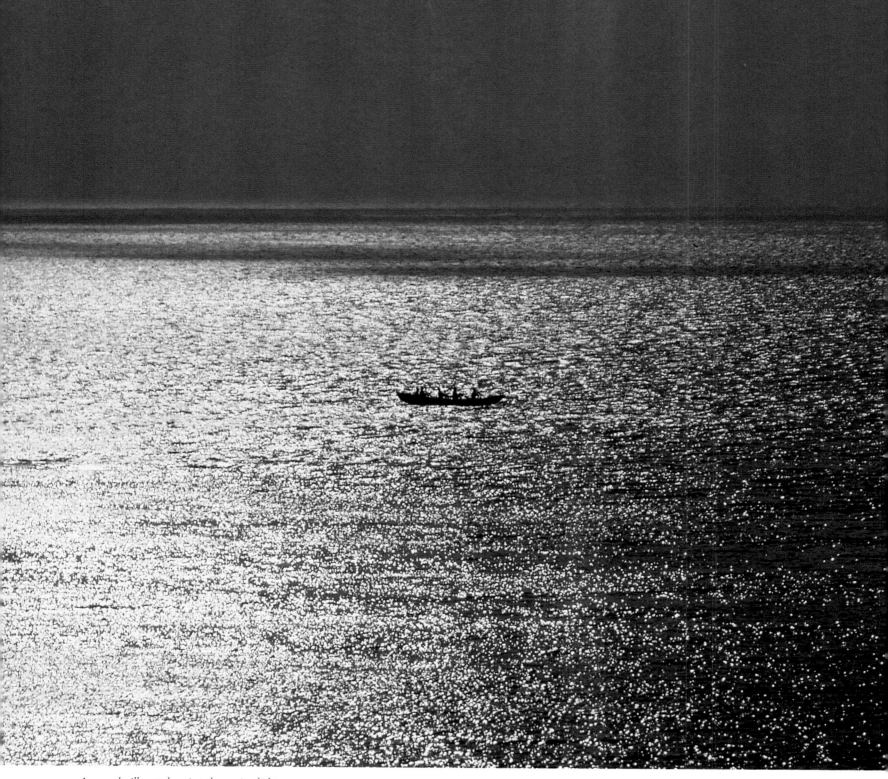

A curragh silhouetted against the evening light.

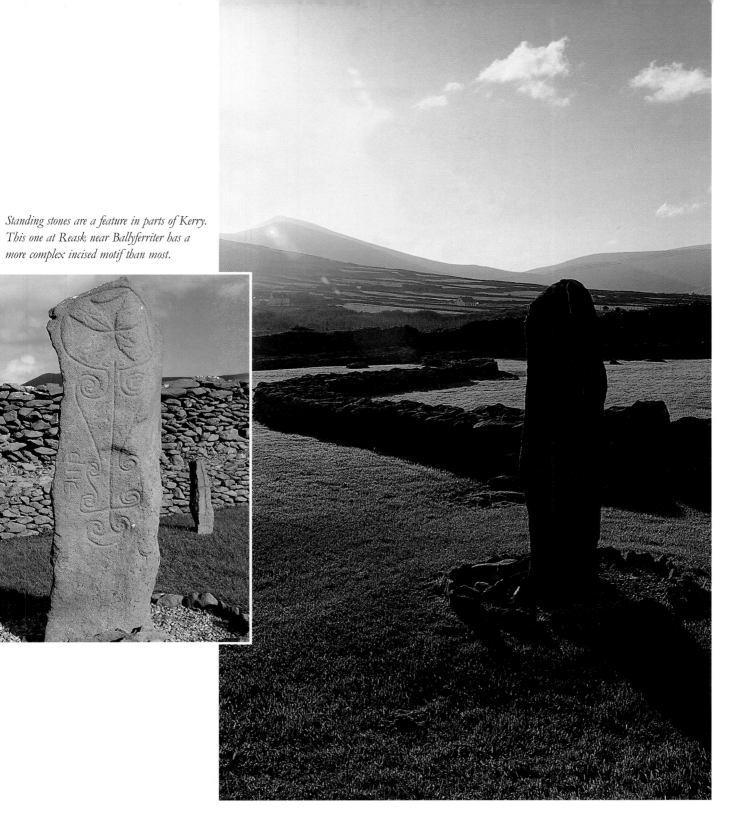

Standing stones are a feature in parts of Kerry. This one at Reask near Ballyferriter has a more complex incised motif than most.

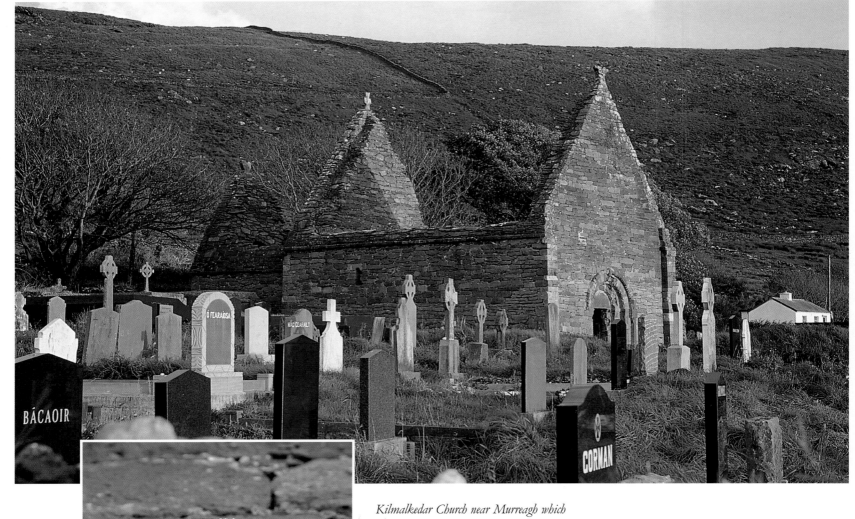

*Kilmalkedar Church near Murreagh which
overlooks Smerwick Harbour and in its earliest
form probably dates from the seventh century.
Sculptured heads are a feature of the Romanesque
doorway.*

*Facing page: Minard
Castle, on the shores of
Dingle Bay between
Dingle and Anascaul,
was once the largest
fortress on the Dingle
Peninsula.*

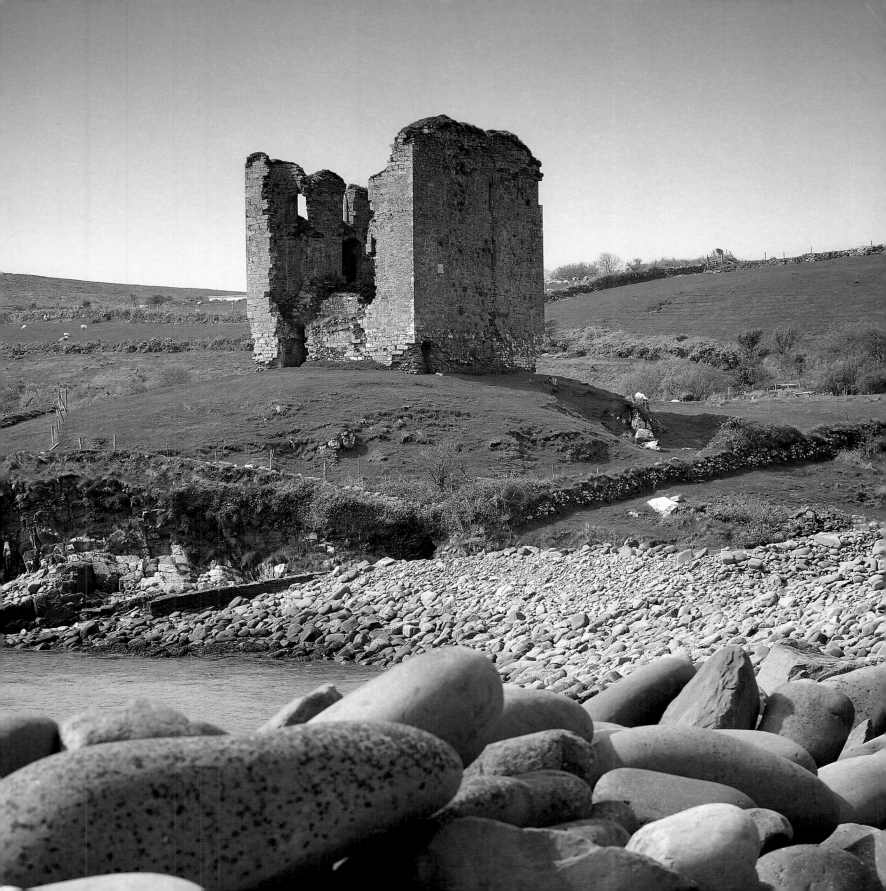

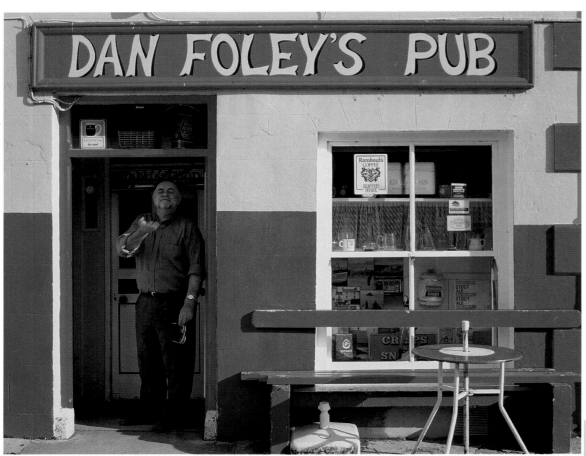

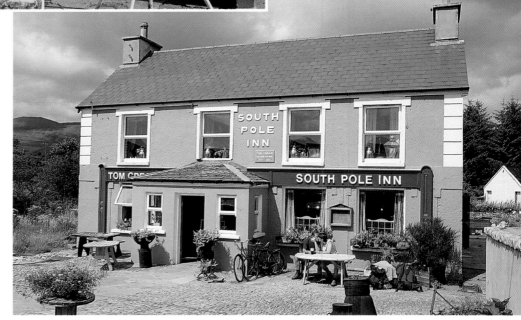

Dan Foley's pub in Anascaul must be one of the most colourful while the South Pole Inn was established by one of Kerry's most famous sons, Tom Crean, who survived three expeditions to the Antarctic with Scott and Shackleton.

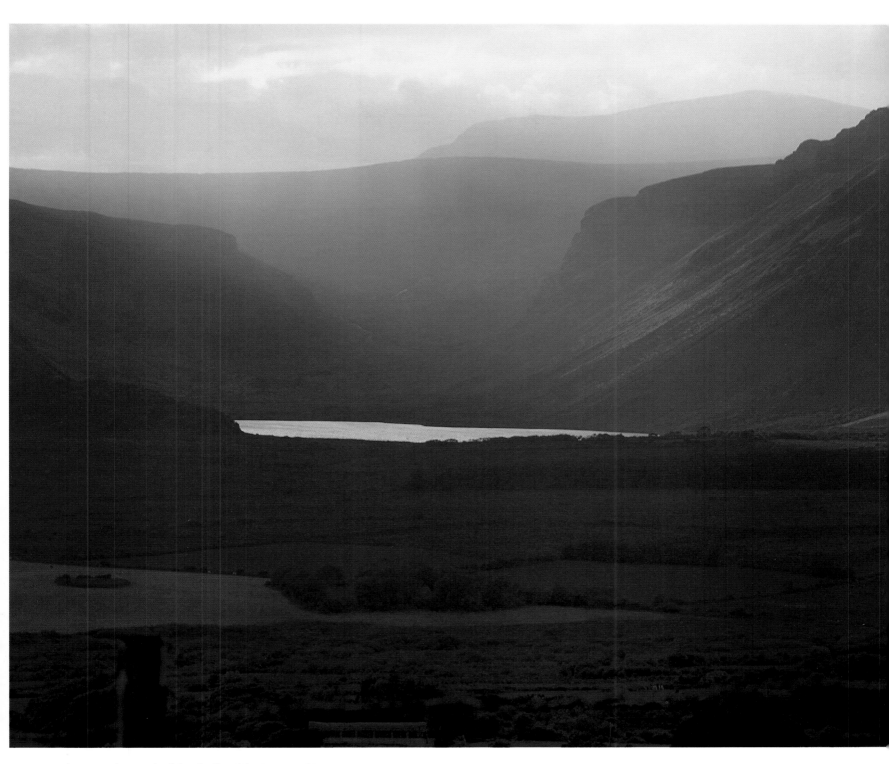

Lough Anascaul sits in the sheltered valley of the Owenascaul River.

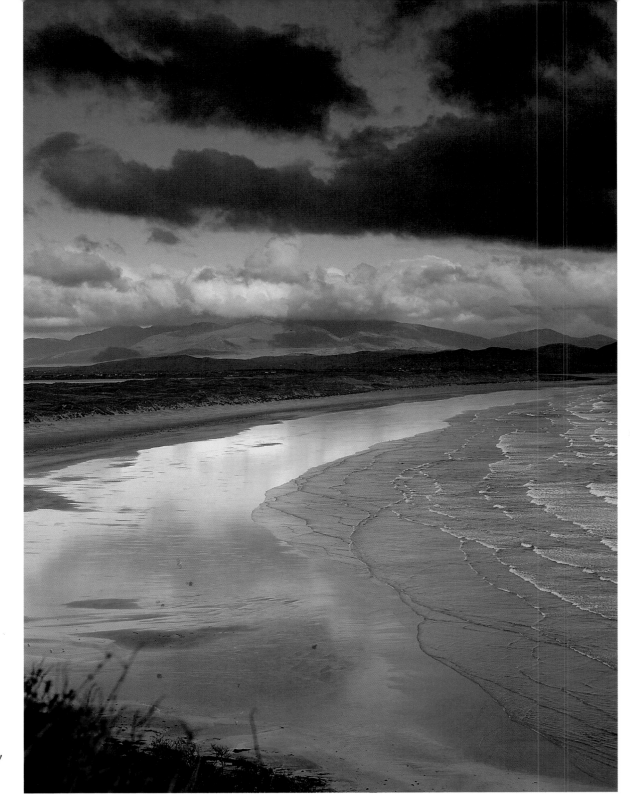

*The magnificent Inch Strand where some of John Millington Synge's **The Playboy of the Western World** was filmed.*

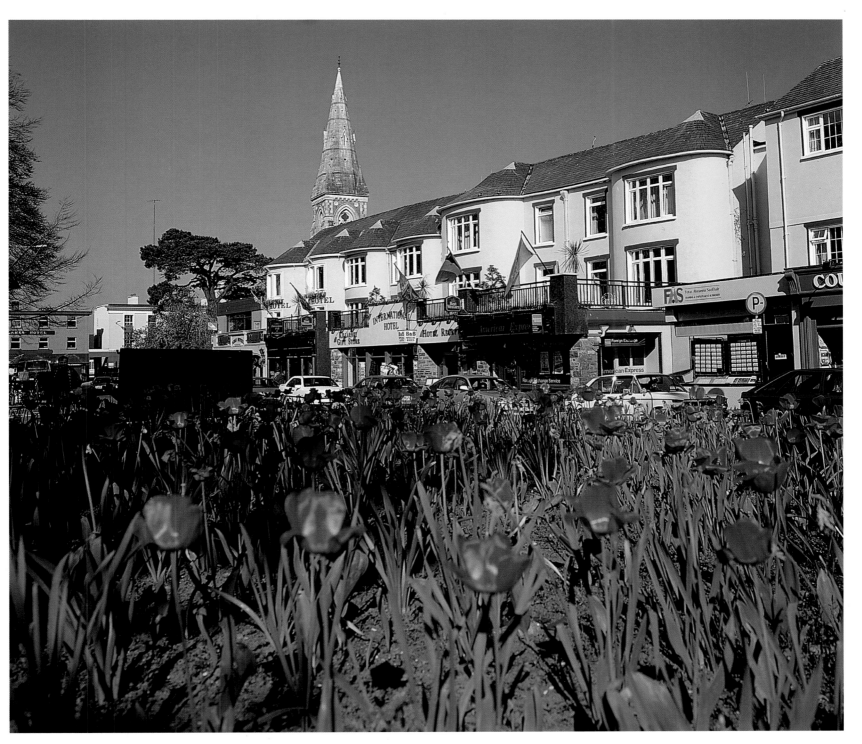

Killarney, the tourist capital of Kerry, can be particularly beautiful in spring as evidenced by this display of tulips.

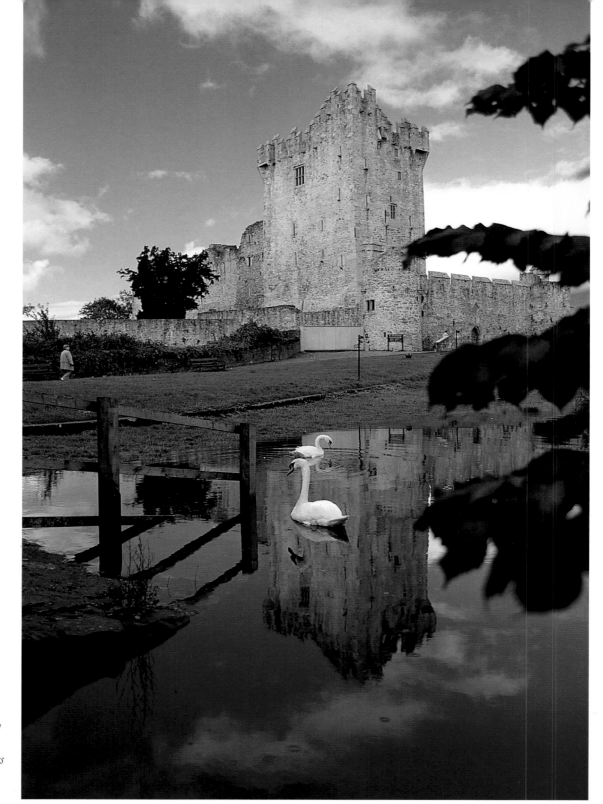

Ross Castle, on the shores of Lough Leane or the Lower Lake, was built by the O'Donoghue clan in the sixteenth century. It has recently been restored and opened to the public.

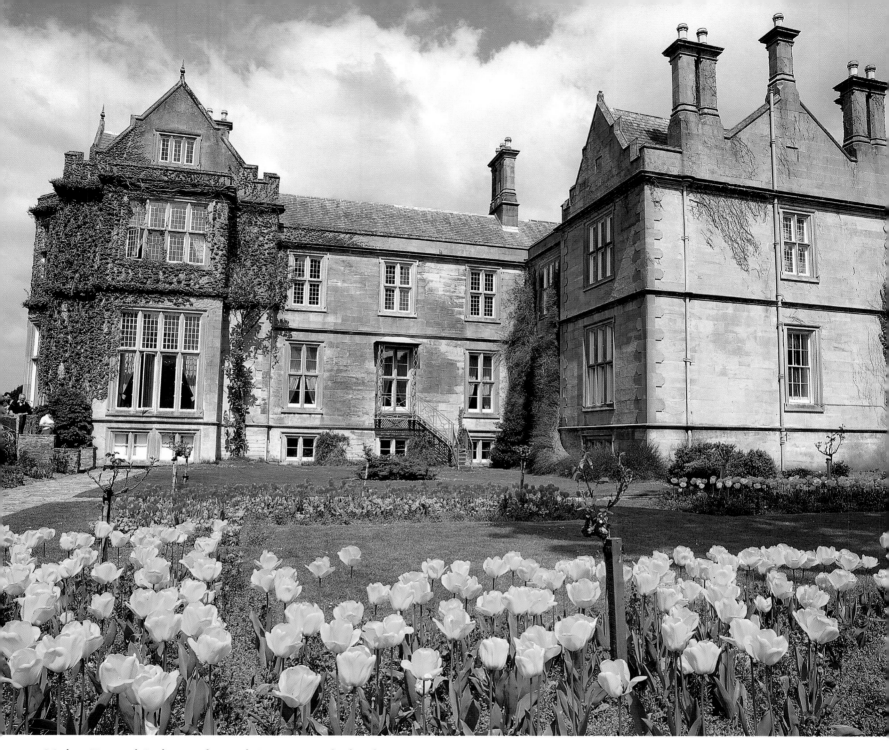

Muckross House and Gardens, once home to the Bourne-Vincent family and now part of Killarney National Park, are open to the public. Muckross House has a fine collection of antiques, gift shops and a restaurant.

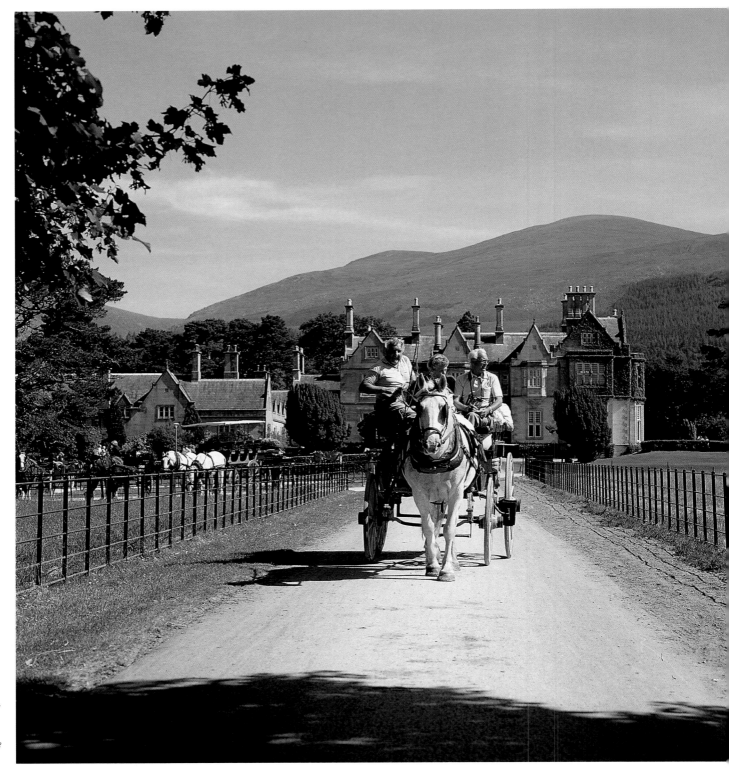

Exploring the grounds of
Muckross Demesne by
jaunting car is a favourite
pastime with visitors.

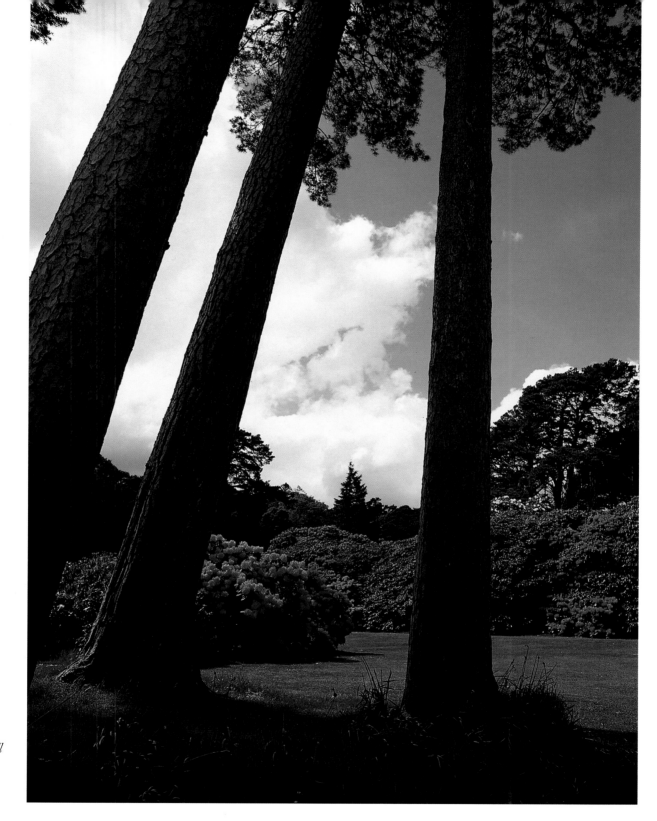

Rhododendron in full bloom in Muckross Gardens framed by majestic Scots pines.

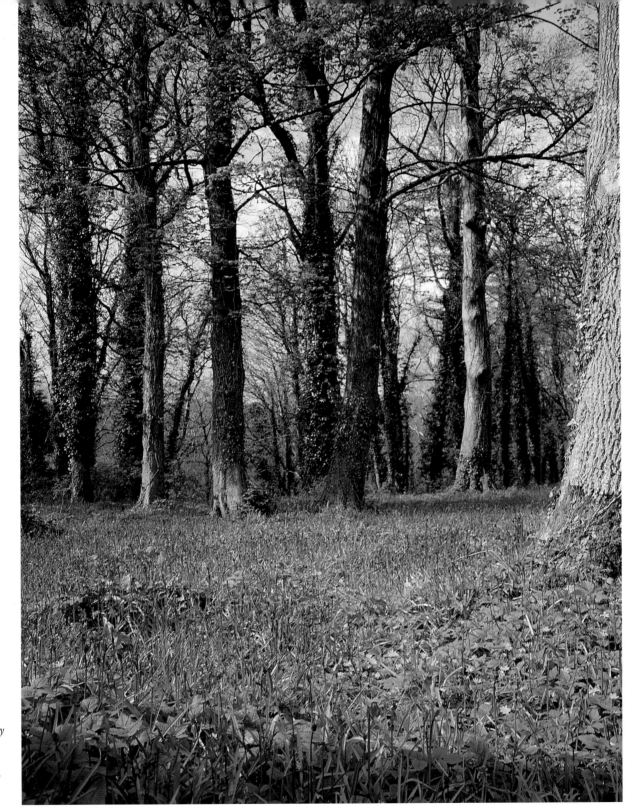

Nature bursts forth in springtime in Killarney National Park where bluebells grow in profusion accompanied by wild garlic.

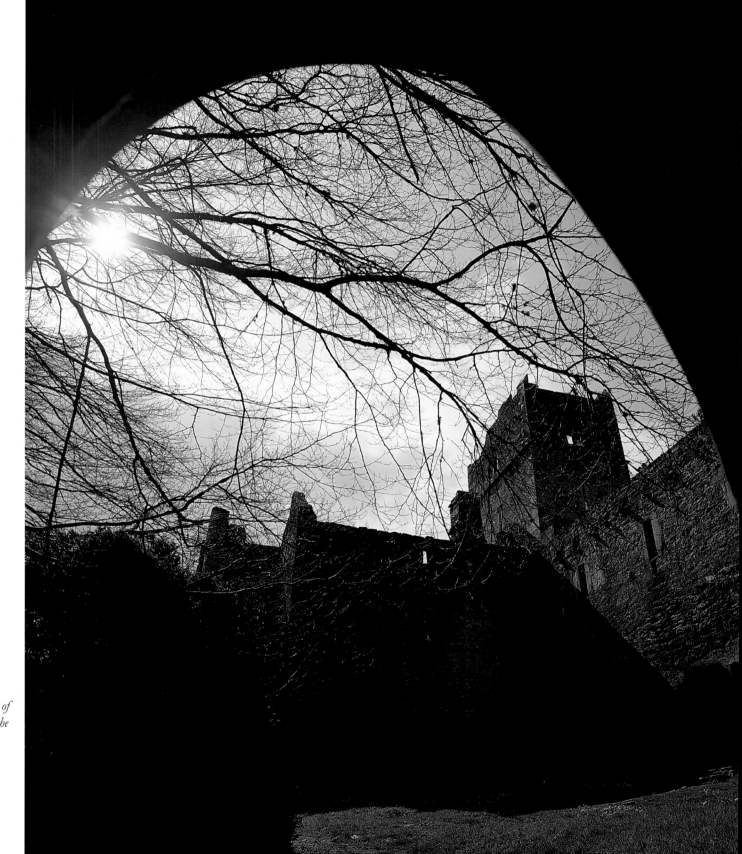

Muckross Abbey on the shores of Muckross Lake was built for the Franciscans in the fifteenth century and is one of the finest examples of its kind.

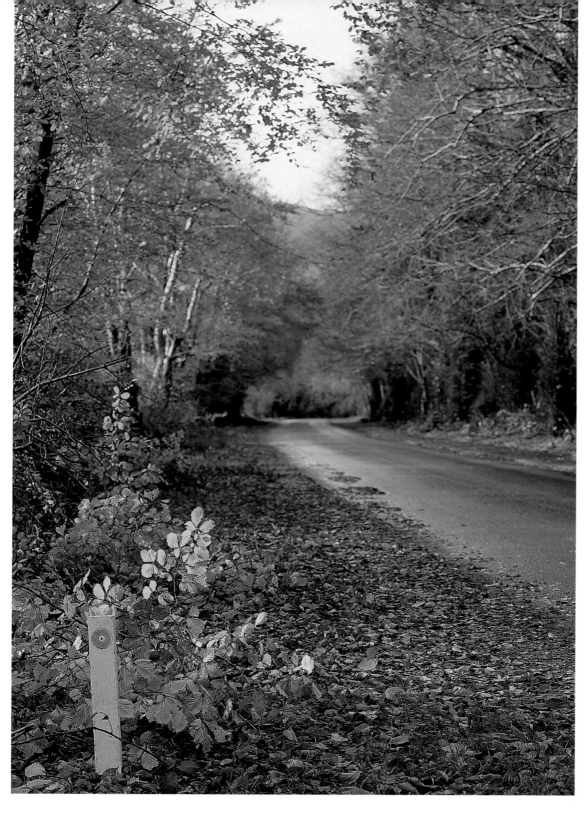

Autumn colours abound in Killarney National Park.

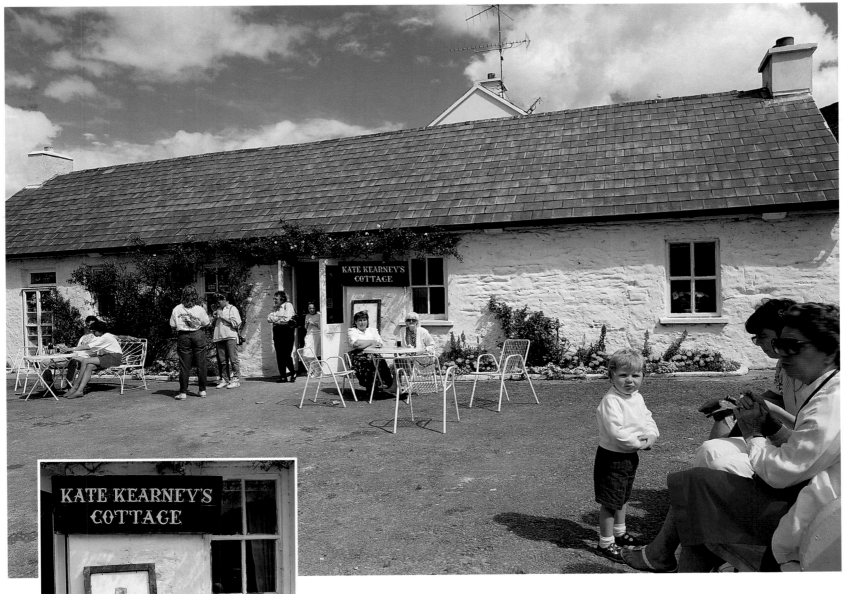

Kate Kearney's Cottage is a popular
destination for tourists and visitors, set
amidst majestic mountain scenery at
the northern end of the Gap of Dunloe

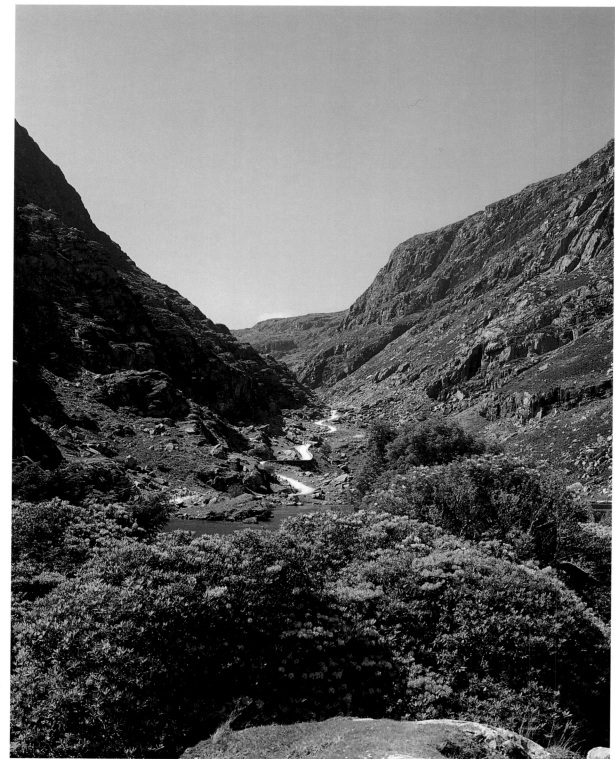

The winding Gap of Dunloe, starting at Kate Kearney's Cottage, is synonymous with a visit to Killarney and the Macgillycuddy's Reeks.

A winter scene in the Black Valley or Cummeenduff, south of the Gap of Dunloe.

The Beaufort Bar, just off the Killarney-
Killorglin road, is a fine, well-maintained
Irish pub and restaurant.

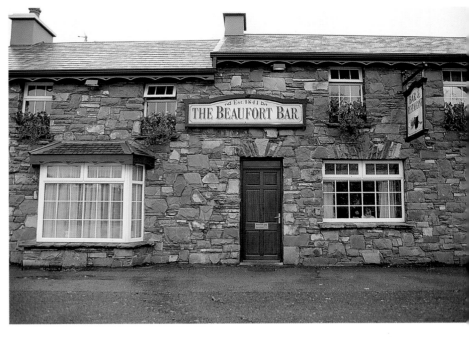

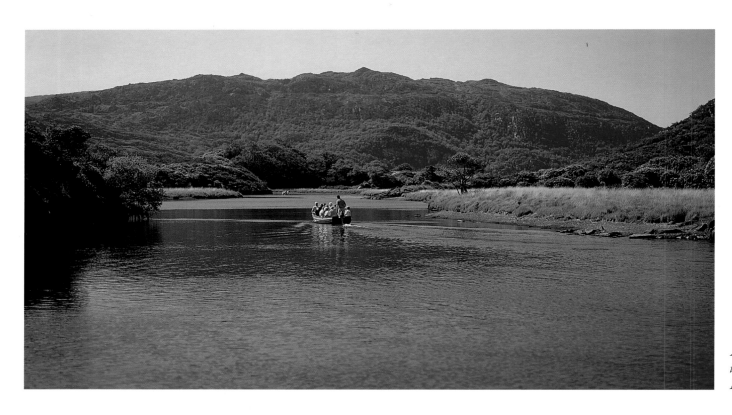

A trip by boat through the Long Range at the Meeting of the Waters.

Light and autumn colours blend to make the Upper Lake and the Long Range a spectacle.

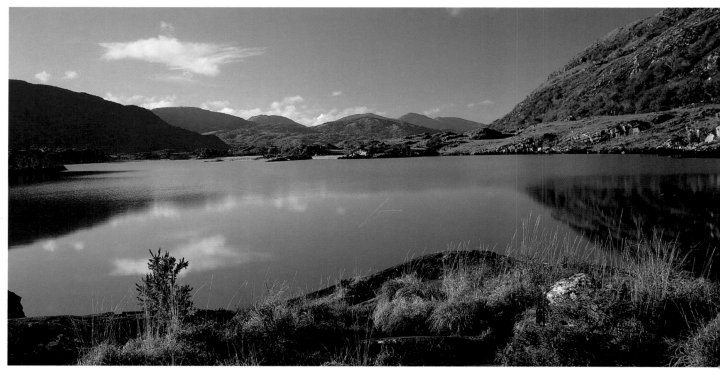

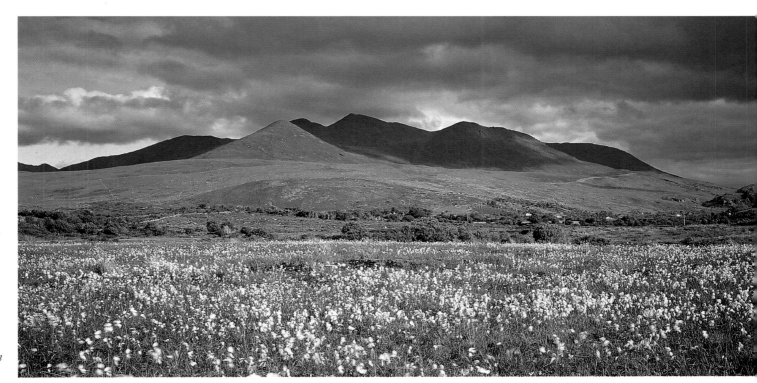

Glencar and the Macgillycuddy's Reeks act as a backdrop to a profusion of bog cotton in spring.

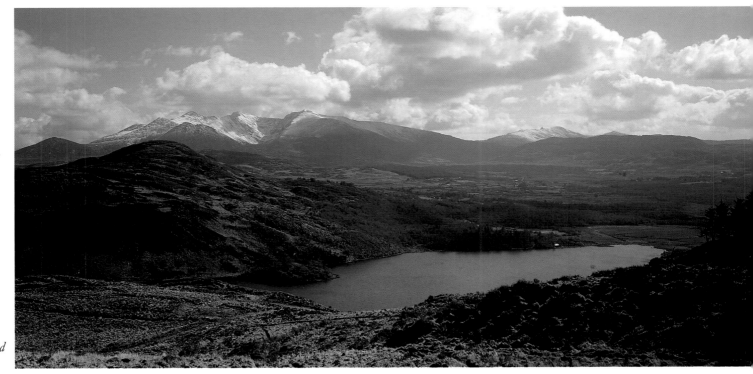

Caragh Lake and Glencar overlooked by the snow-capped Macgillycuddy's Reeks.

*Fallen autumn leaves
near Glenbeigh
indicate the imminent
arrival of winter.*

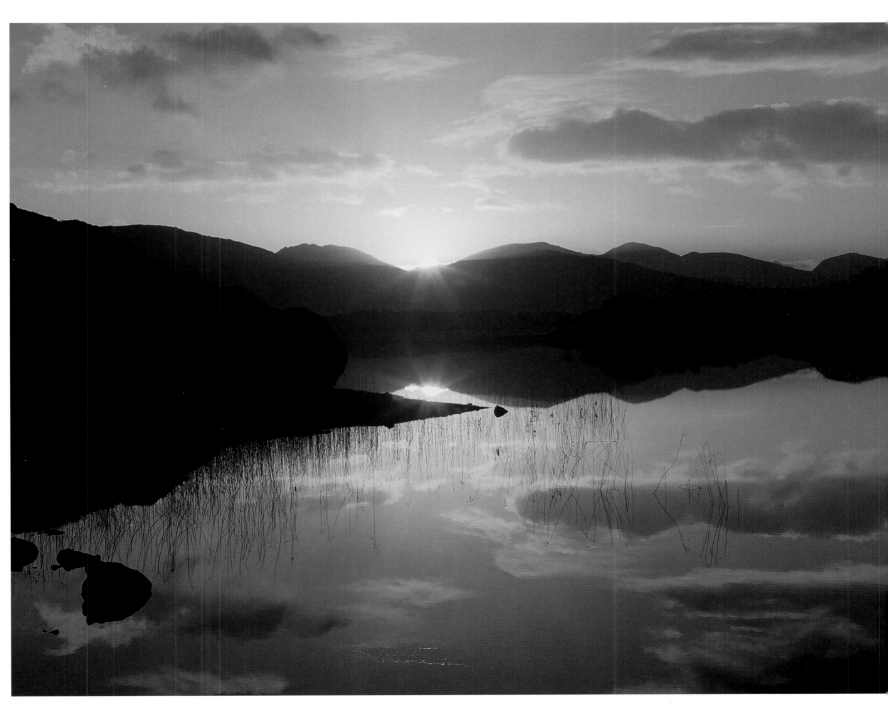

*The last rays of the evening sun reflect on the Long Range just off the
Killarney-Kenmare road.*

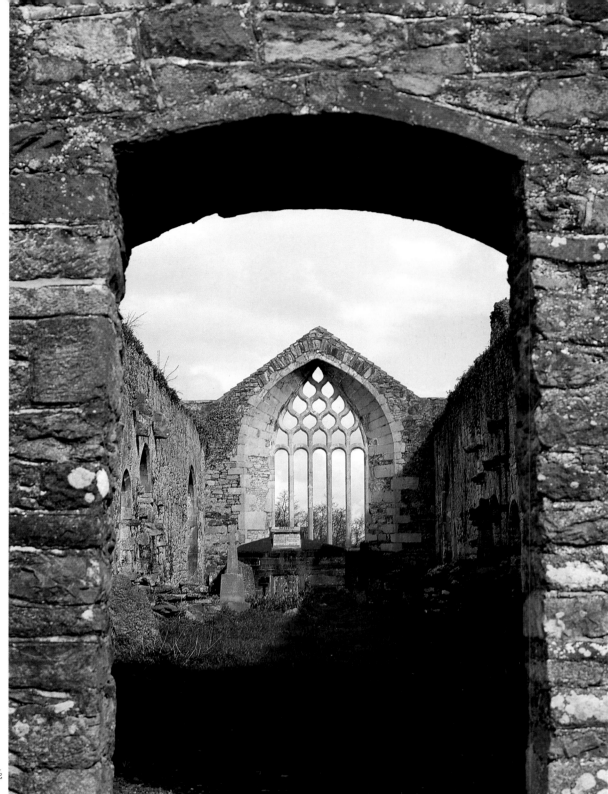

The remains of the Augustinian Abbey at Kilcolman near Milltown, once one of the richest in Ireland, overlook Castlemaine Harbour.

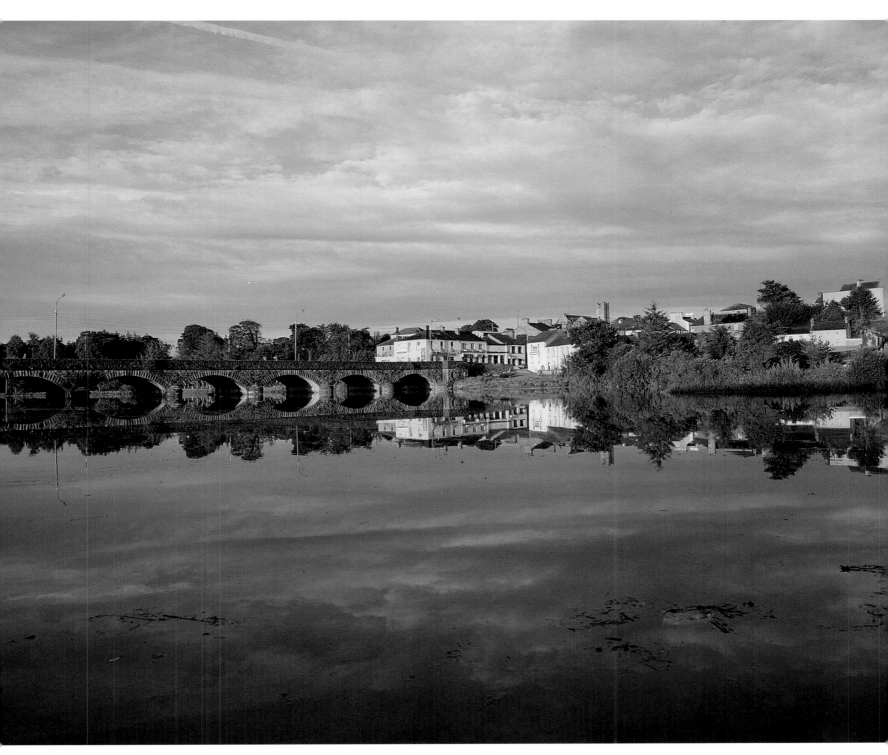

Killorglin on the banks of the River Laune is famous for its annual Puck Fair,
held each August and believed to date back to pre-Christian times.

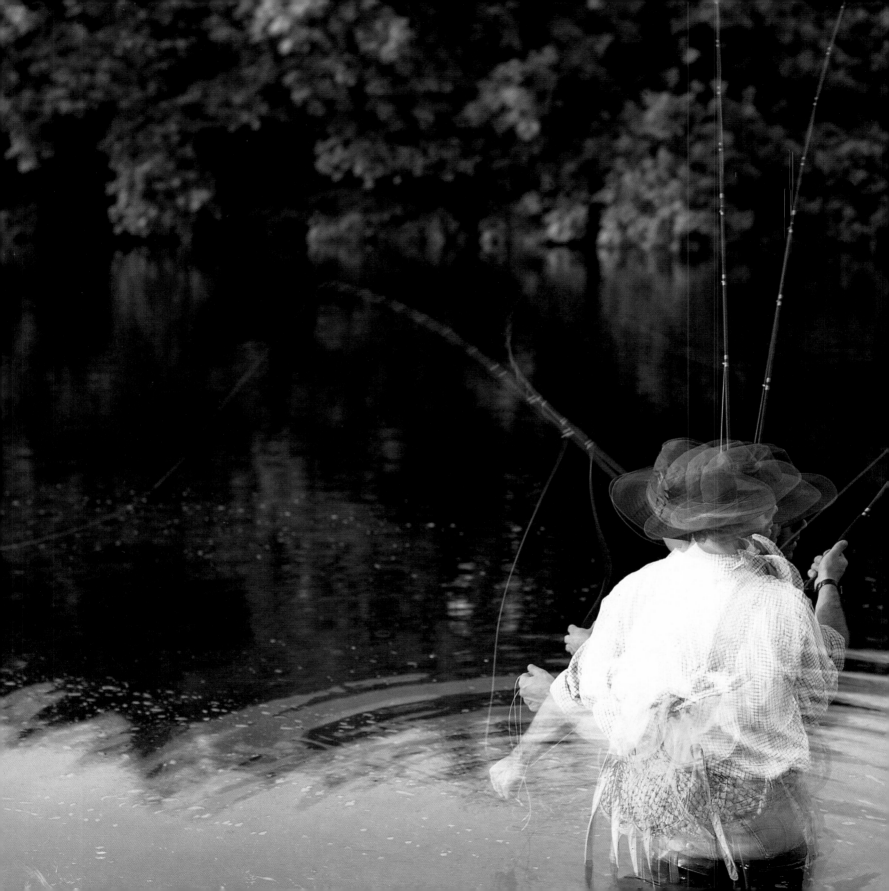

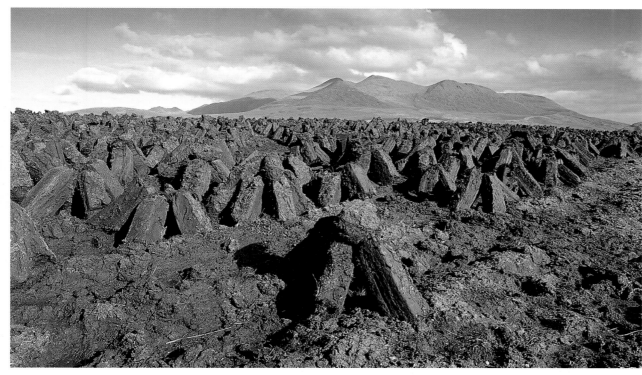

Peat or turf harvesting on the bogs is an annual event. Sods of turf are cut, then stacked or 'stooked' to dry and drawn from the bogs for use as domestic fuel.

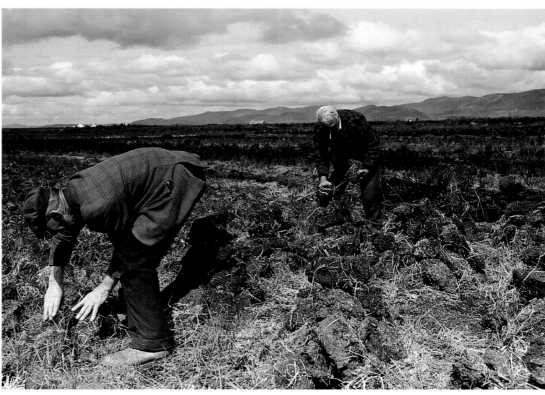

Facing page: In Kerry rivers, lakes and sea provide endless scope for recreation. Here the River Laune and its inhabitants test the skills of this fly-fisherman.

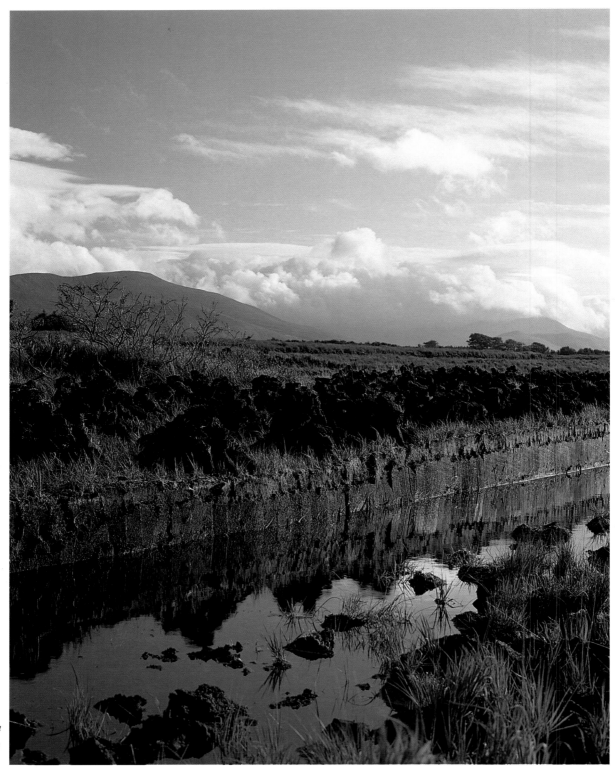

A typical bank of peat from which sods have been cut near Glenbeigh on the Ring of Kerry.

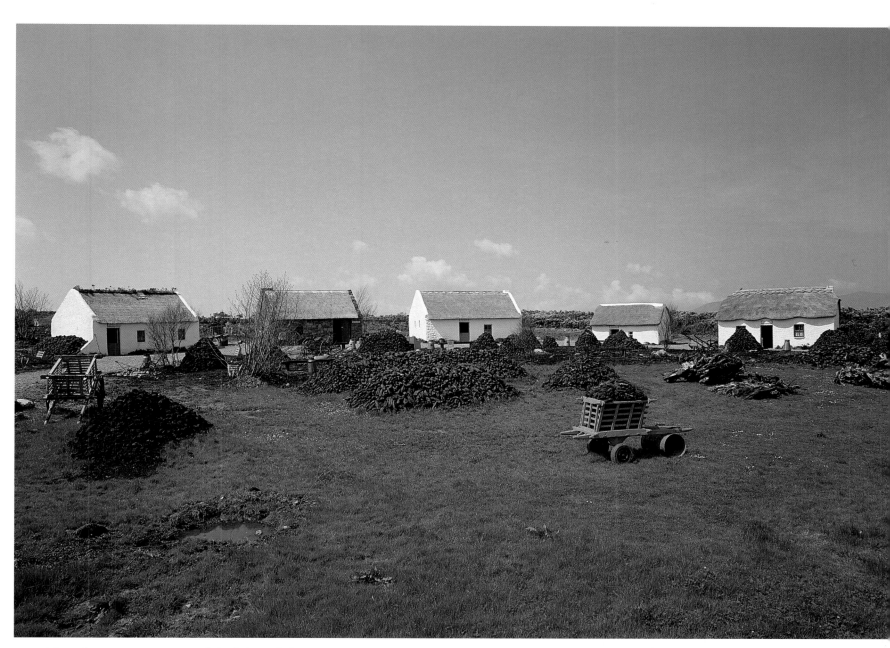

The Red Fox Bog Museum near Glenbeigh depicts the harvesting
and use of turf in the traditional style, both indoors and outdoors.

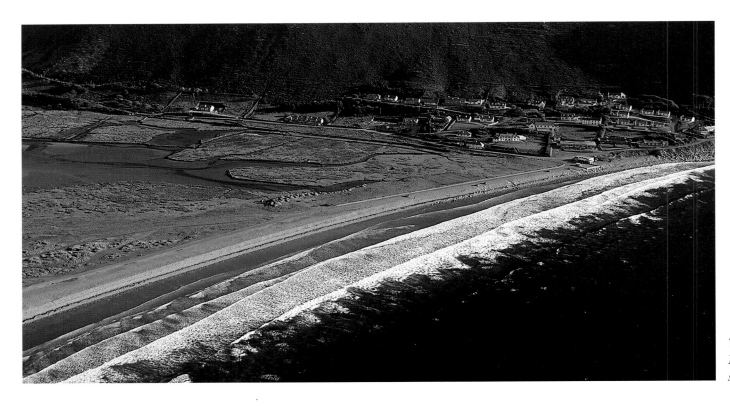

The splendid Rossbeigh Beach extending along the sandspit for over three km.

Cromane Point where the Rivers Laune and Maine enter the sea in Dingle Bay.

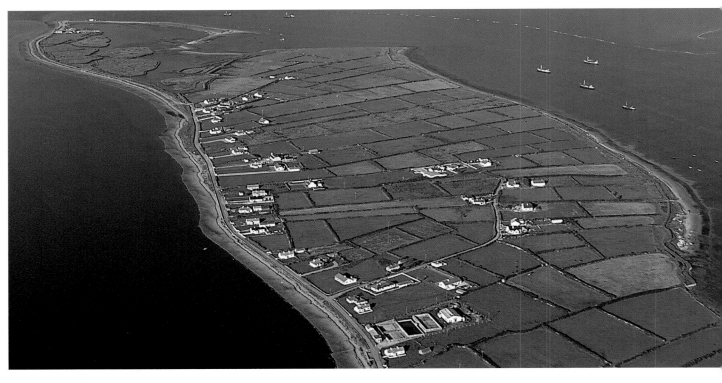

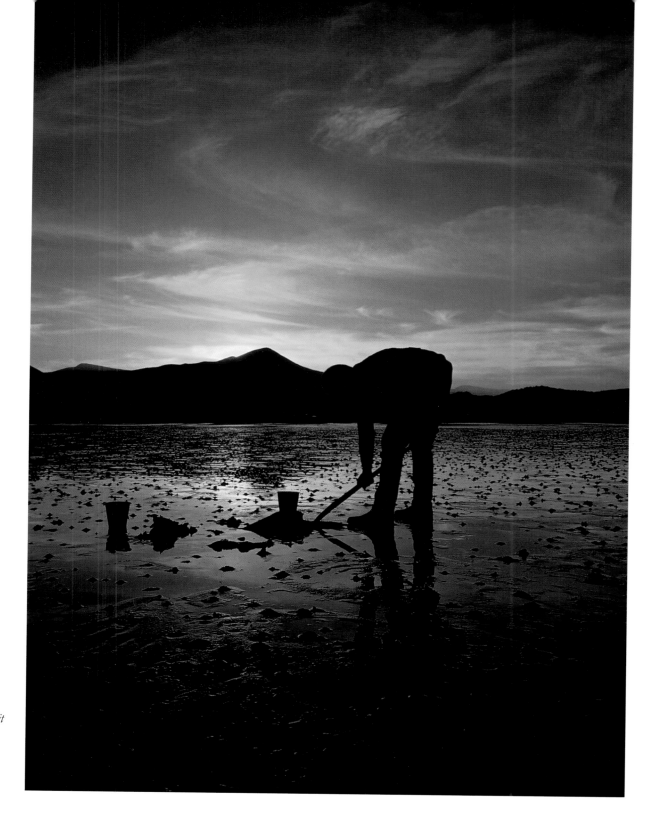

*A fisherman digs bait
on Rossbeigh Beach
silhouetted against the
worm mounds and
the mountains.*

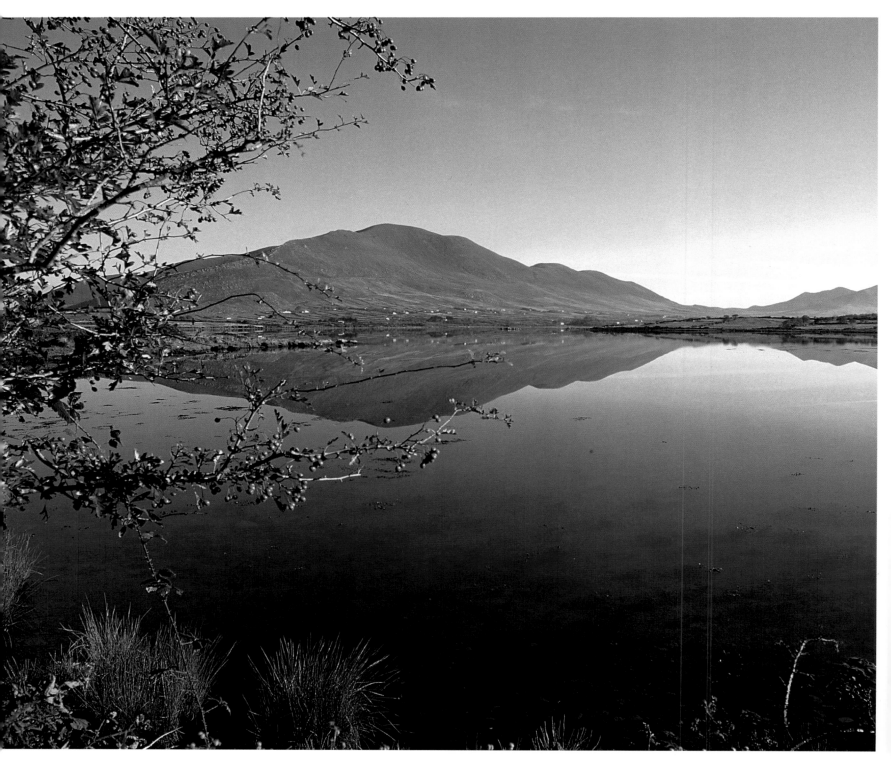

Caherciveen Harbour and a view known locally as 'Over The Water'.

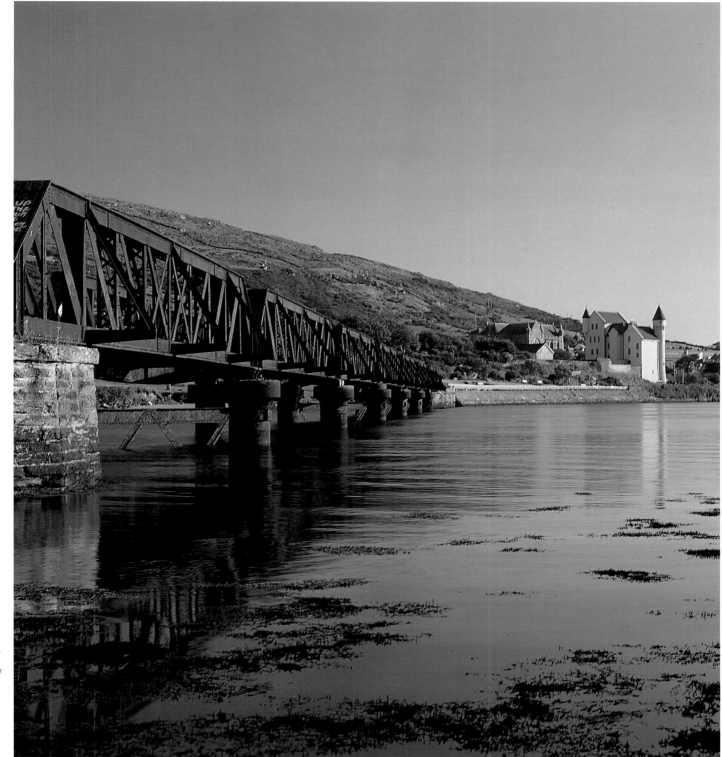

One of the last remaining bridges of the South Kerry Railway. The former police barracks stood abandoned for many years but is now open as a museum.

83

Kerry in Pictures

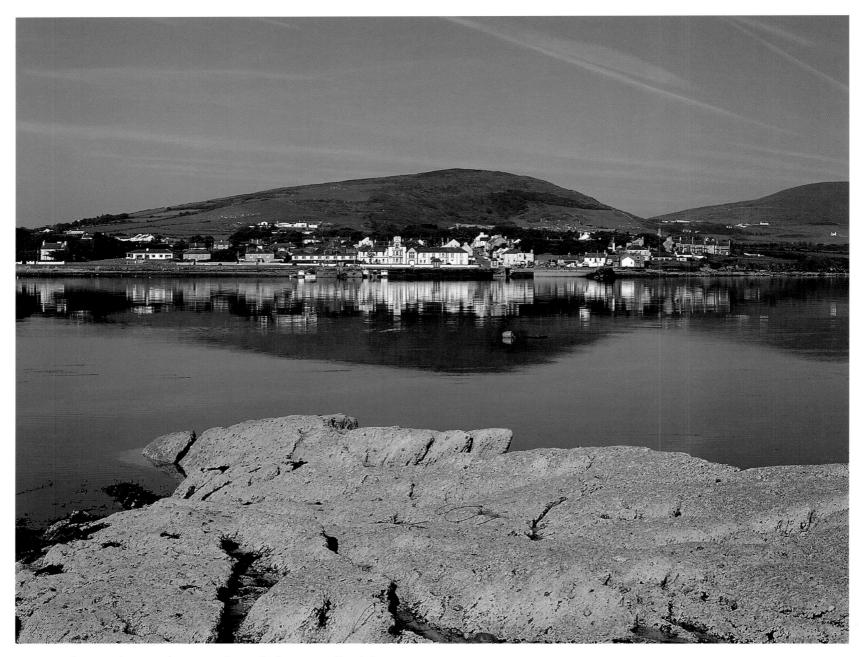

Knightstown is the principal town on Valencia Island, once accessible only by boat but now by bridge and ferry. It was from here the first transatlantic cables were lain in 1866. This story and much else is told in the village museum.

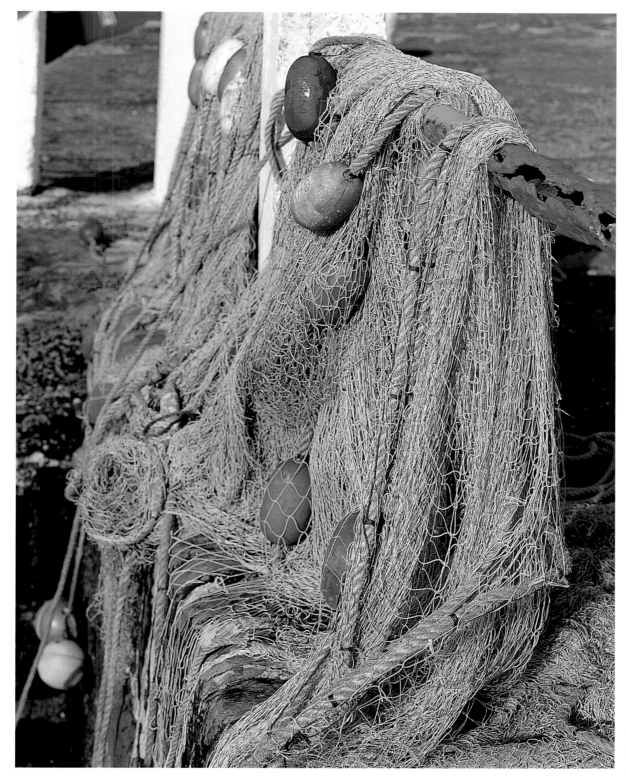

Fishing nets out to dry at Knightstown Harbour.

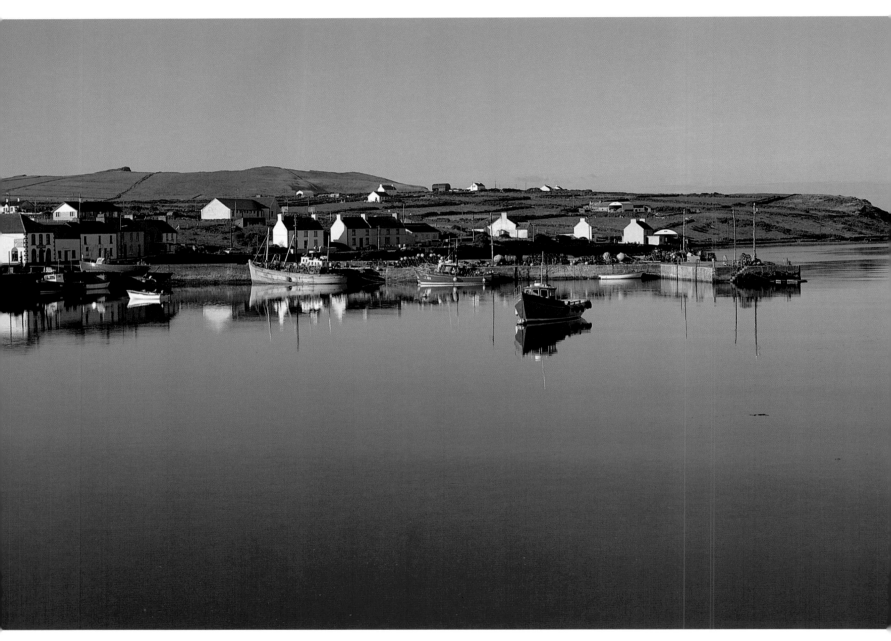

Picturesque Portmagee at the entrance to Valencia Sound is the site of the fine Skellig Interpretative Centre.

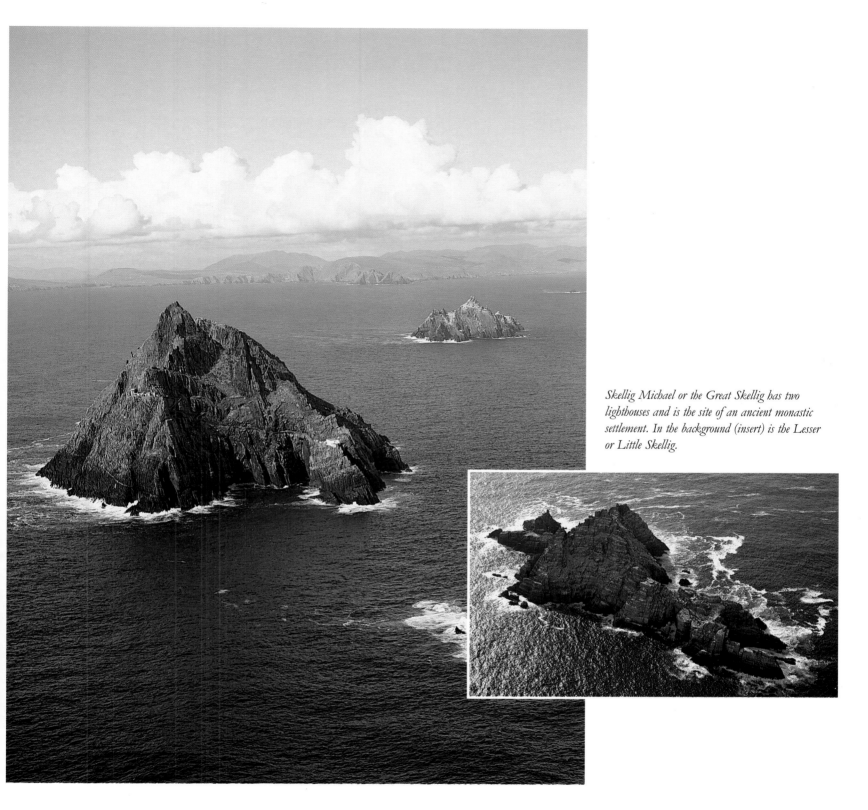

Skellig Michael or the Great Skellig has two lighthouses and is the site of an ancient monastic settlement. In the background (insert) is the Lesser or Little Skellig.

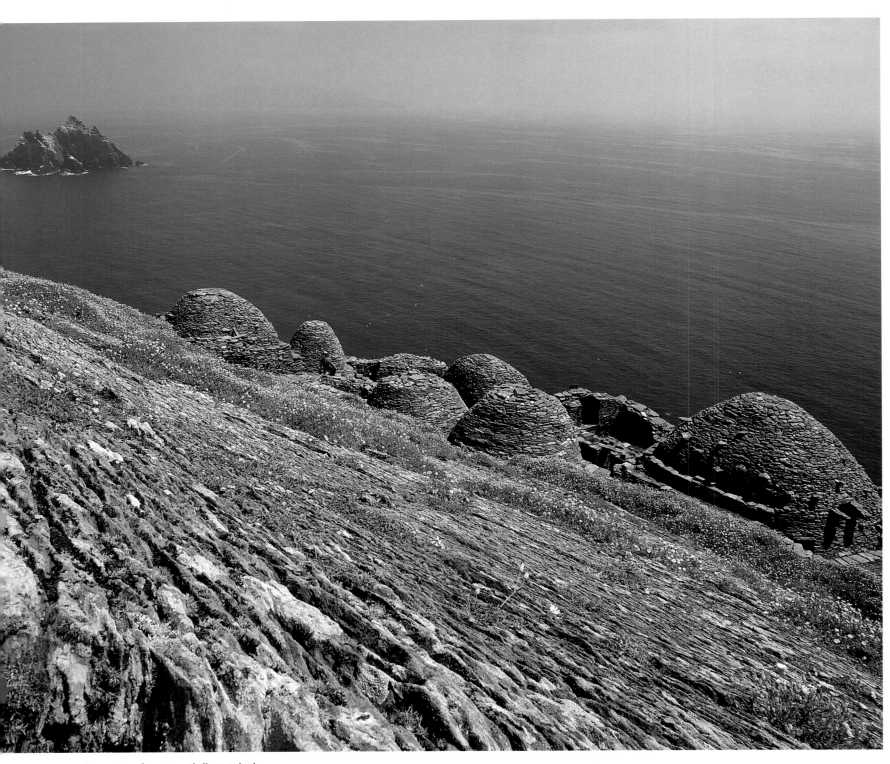

Monastic settlement on Skellig Michael.

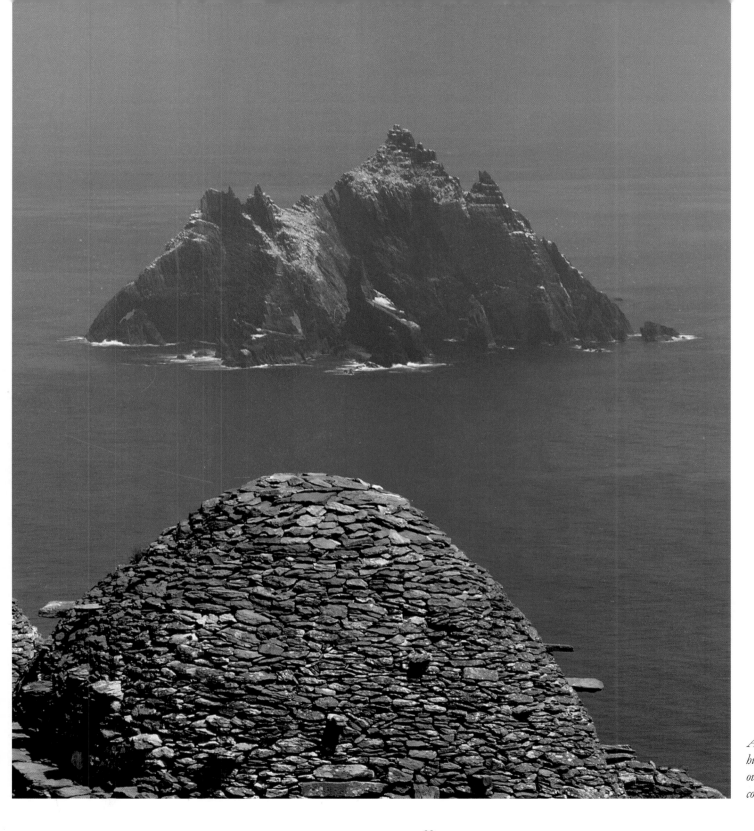

An ancient monastic hut on Skellig Michael overlooks the gannet colony on Little Skellig.

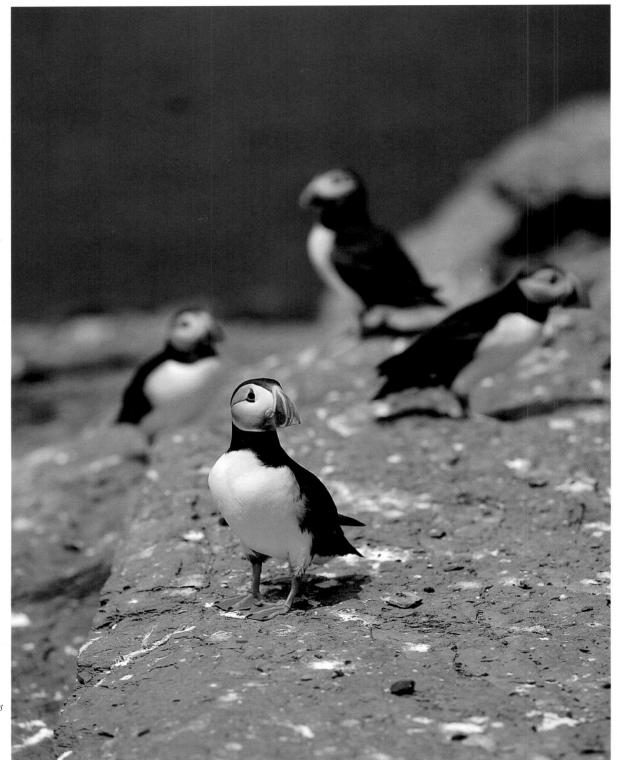

Summer visitors to the Skelligs include the colourful puffins, sometimes known as sea-clowns, who come here to breed in their thousands.

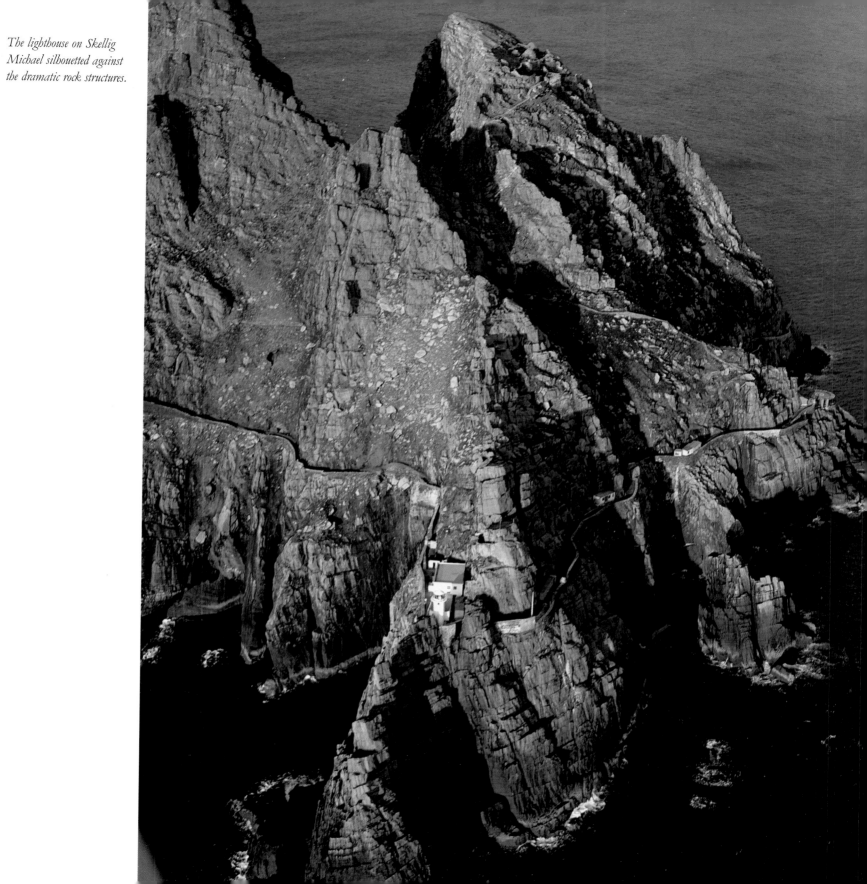

The lighthouse on Skellig Michael silhouetted against the dramatic rock structures.

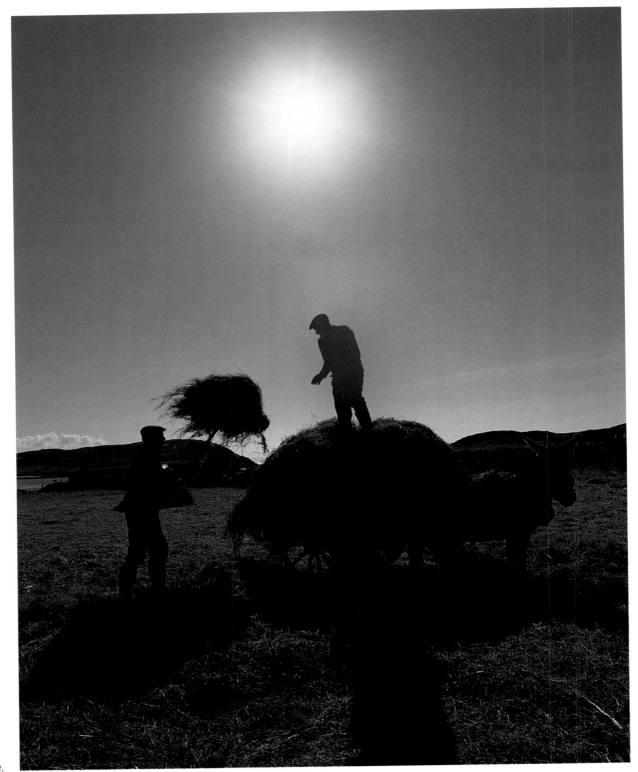

*Bringing home the
hay near Caherciveen.*

The old field and cultivation patterns stand out on Horse
Island near Ballinskelligs.

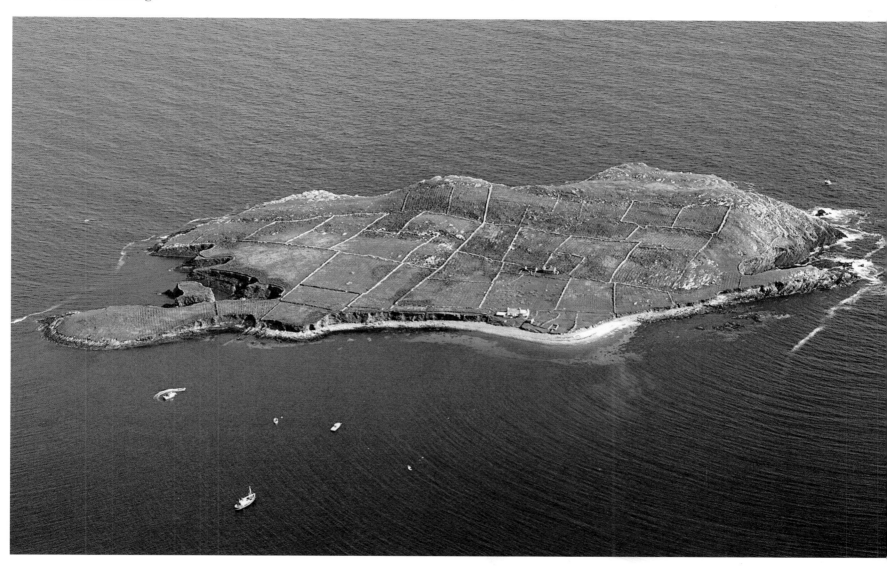

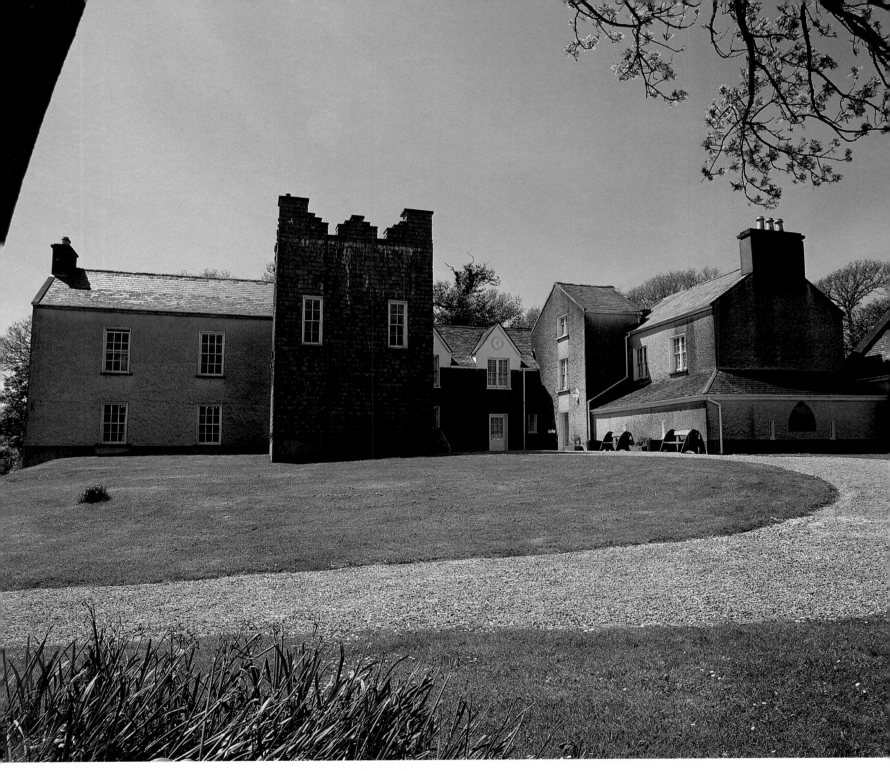

Derrynane House (Abbey), once the home of Daniel O'Connell (1775-1847), who won emancipation for Catholics, is now in state ownership and open to visitors.

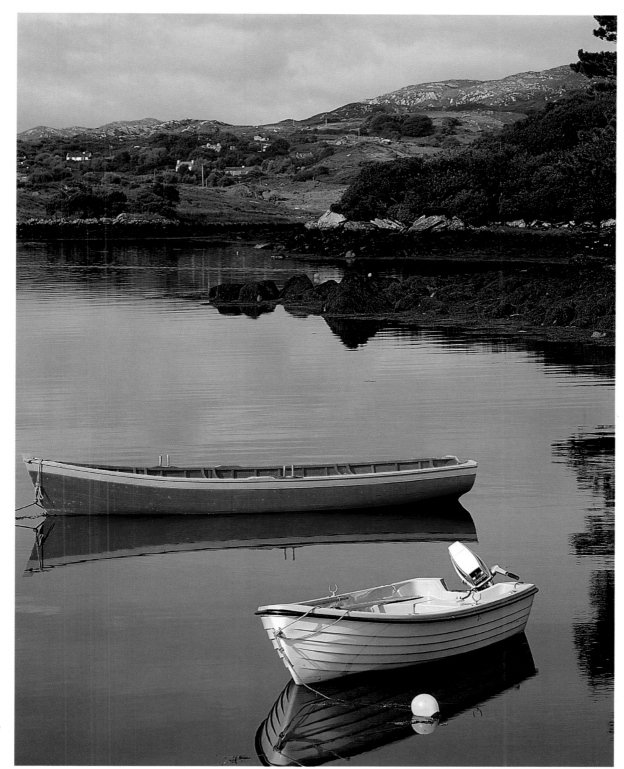

Sheltered inlets on the Kenmare River estuary offer suitable scope for leisure boating.

Facing page: The well-preserved Staigue Fort, near the village of Castlecove, is a fine example of an early pre-Christian defensive structure.

Pubs in Kerry are often painted in a variety of attractive colours as is the case with this pub in Sneem.

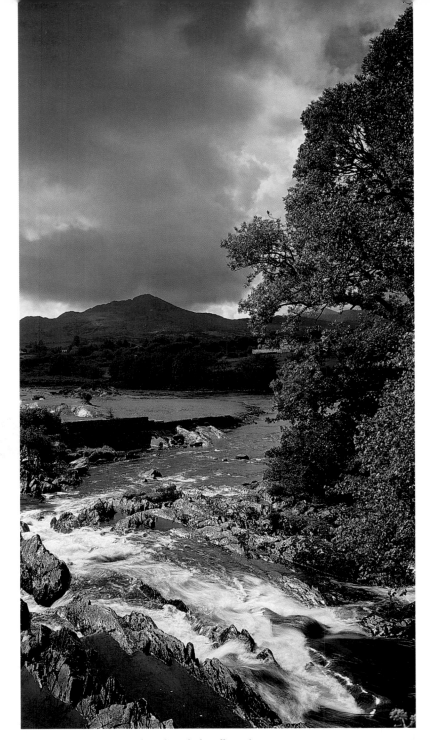

The Sneem River, which flows through the village of Sneem, is a famous salmon river.

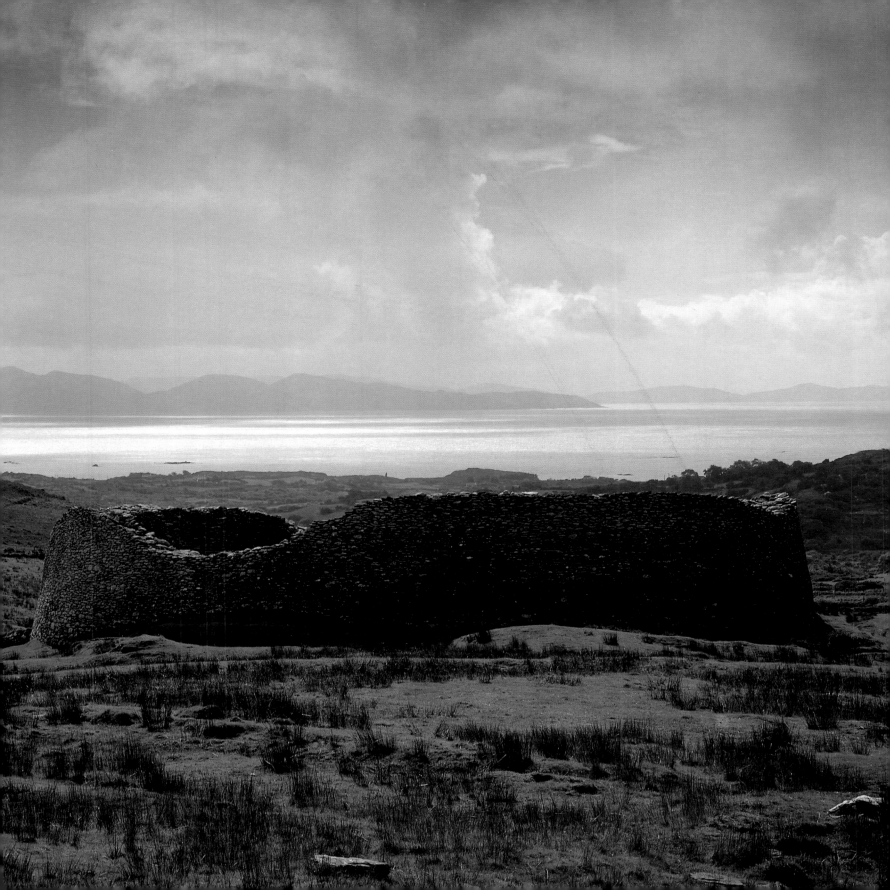

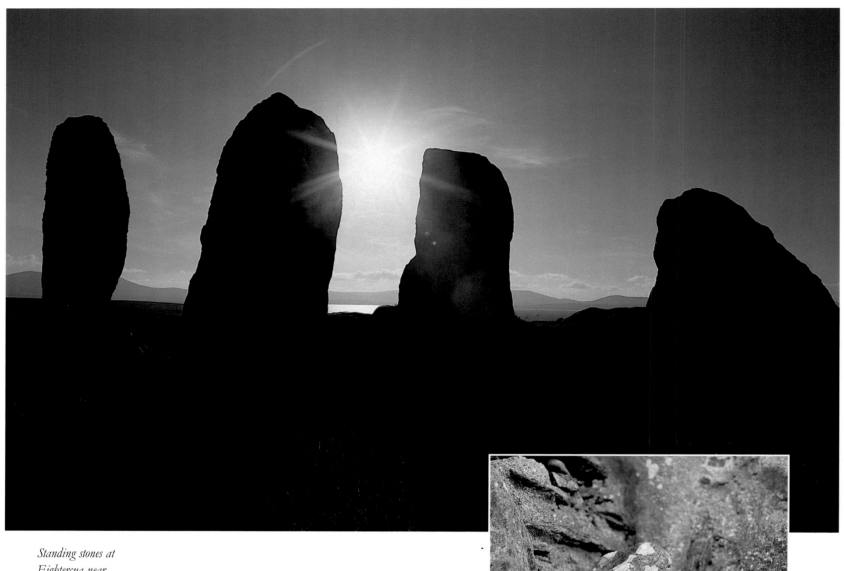

Standing stones at Eightercua near Waterville.

St Fionan's Church on Church Island in Lough Currane has a number of figures built into its walls including this sculpture of a head.

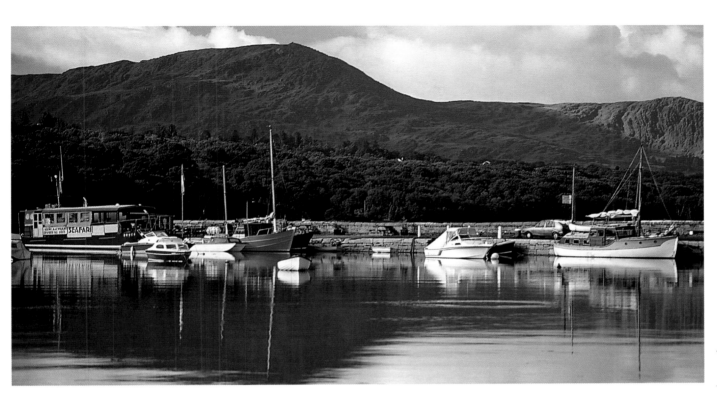

The pleasant town of Kenmare is a tourist and gourmet centre. Trips down the estuary from the picturesque pier are popular in season.

Straddling the Roughty River just outside Kenmare is one of Ireland's first suspension bridges.

Kerry in Pictures

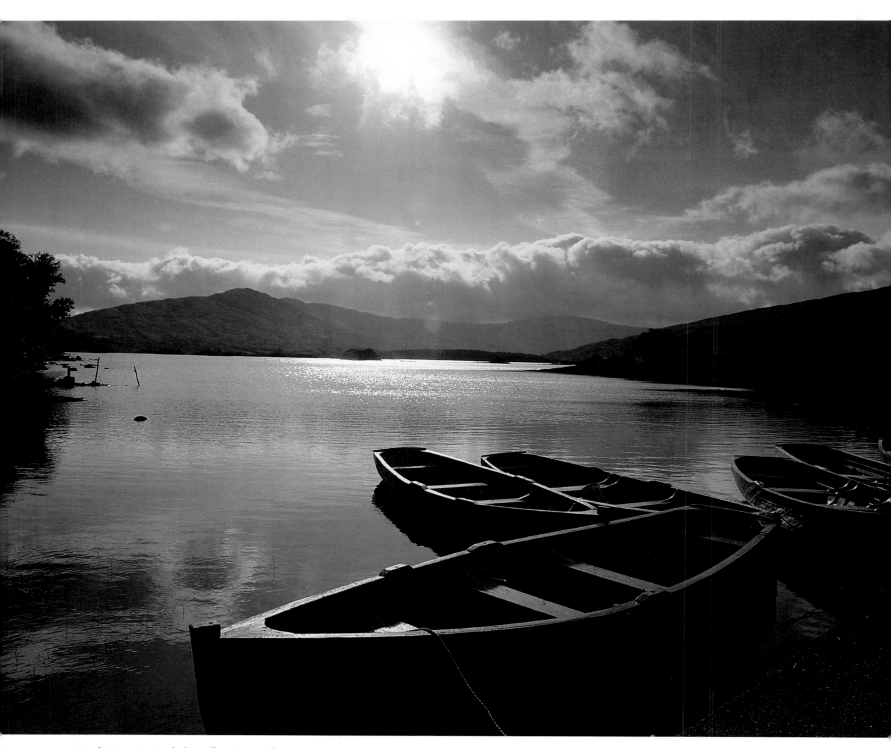

*On the Beara Peninsula but still in Kerry, Cloonee
Lakes are still and peaceful as a new day dawns.*

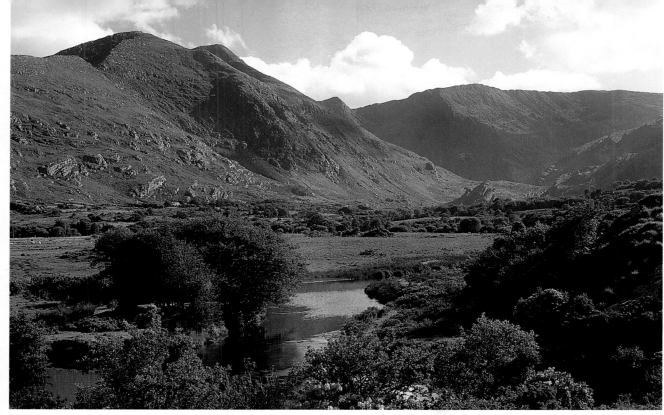

Tucked away in a remote corner of the Beara Peninsula under the shadows of the Caha Mountains is peaceful Glanmore Valley.

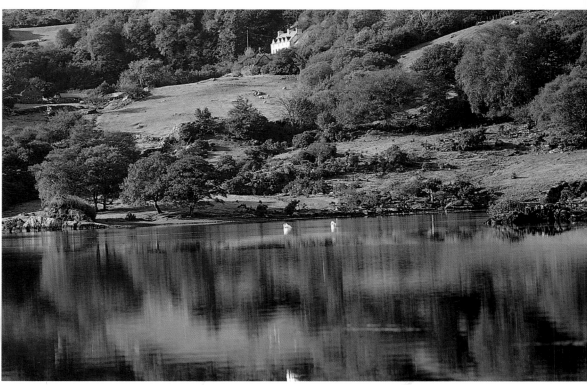

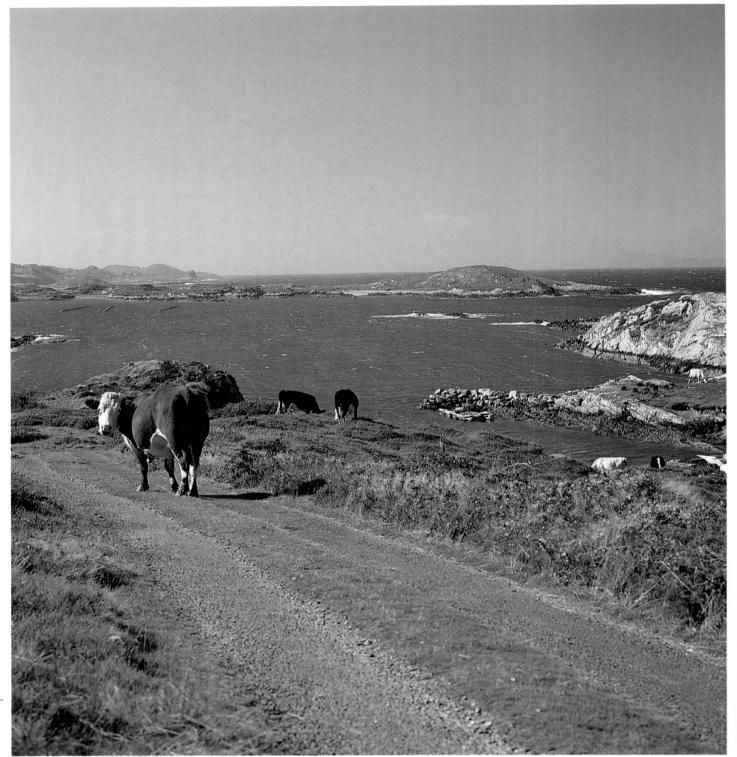

Ardgroom on the Beara Peninsula, with views of the open Atlantic, is one of the least busy places in Kerry.